Painting the Middle East

CONTEMPORARY ISSUES IN THE MIDDLE EAST

Painting the MIDDLE EAST

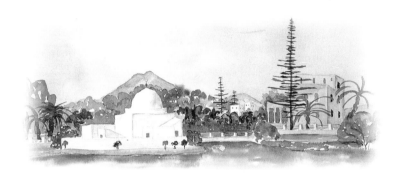

With a Foreword by

SUSAN KERR VAN DE VEN

SYRACUSE UNIVERSITY PRESS

Library of Congress Cataloging-in-Publication Data

Kerr, Ann Zwicker, 1935–
 Painting the Middle East / Ann Zwicker Kerr ; with a foreword by Susan
Kerr van de Ven.—1st ed. 2002.
 p. cm.—(Contemporary issues in the Middle East)
 ISBN 0-8156-0752-0
1. Middle East—Description and travel. 2. Africa, North—Description
and travel. 3. Middle East—Pictorial works. 4. Africa,
North—Pictorial works. 5. Kerr, Ann Zwicker, 1935—Journeys—Middle
East. 6. Kerr, Ann Zwicker, 1935—Journeys—Africa, North. I. Title.
II. Series.
DS47.9 .K47 2002
915.604'4—dc21
 2002013513

For my grandchildren,

Johan, Derek, Nicholas, Madeleine, Willem, and Matthew,

and for those yet to come.

Ann Zwicker Kerr, a native of southern California, has spent a total of fifteen years living, studying, and teaching in the Middle East. She was educated at Occidental College, the American University of Beirut, and the American University in Cairo. Ann is currently at the University of California in Los Angeles, where she coordinates the Fulbright Visiting Scholar Enrichment Program for Southern California. She is a frequent speaker on the Middle East and an escort for student groups to the region. Her late husband, Malcolm Kerr, was the president of the American University of Beirut and was assassinated in office in 1984. She is the mother of four adult children. Her first book, *Come with Me from Lebanon: An American Family Odyssey*, was also published by Syracuse University Press.

Contents

Donors

This book is published with the assistance of a grant from Ahmad El-Hindi, as a Mohamad El-Hindi Book on Arab Culture and Islamic Civilization.

Catamount Fund, Ltd.

Ghaleb and Rima Daouk

Roy Doumani

Alexander T. Ercklentz

Mary Selden Evans

Max Greenberg

Paul B. Hannon

Dr. and Mrs. James L. Hecht

Richard and Carlene Snyder Howland

Dr. Ray R. Irani

Robert and Betty Irvin

Diana and Paul Jabber

Dr. and Mrs. Joseph J. Jacobs

Philip Jessup

Stina and Herant Katchadourian

Douglas S. and Mary Ann D. Kerr

Philip S. Khoury and Mary C. Wilson

Ann M. Lesch

In memory of The Reverend Ronald Irwin Metz

Anne A. Meyer

Dr. and Mrs. Howard W. Mitchell

Jan and Safwat Montassir

Mary E. Morris

Christine Nagorski

Frances Khirallah Noble

Naomi Shihab Nye

Mary and David Nygaard

Elizabeth and David Ondaatje

Alice Randel Pfeiffer

Calvin H. Plimpton, M.D.

William B. Quandt and Helena Cobban

The James and Betty Sams Family Foundation, Inc.

Tim and Jane Sanders

With good wishes from Joe and Joyce Stein

Ghassan Tueni

Foreword

SUSAN KERR VAN DE VEN

The watercolors that fill the following pages were painted by Ann Zwicker Kerr over a period of forty years, beginning on the eve of motherhood in 1958 and continuing to the present day—well past her early widowhood in 1984, when my father was shot outside his office door at the American University of Beirut.

As a collection, the paintings represent many things. They are testimony to the awesome natural beauty of the part of the world known as the Middle East. They also form a record of a rapidly disappearing architectural landscape in that land. Finally, they say much about one woman's personal evolution through marriage, motherhood, and solitary adult life. The fact that the paintings carry on steadily after the shattering of a happy marriage points to the painter's vitality and independent character.

While her love of painting the Middle East was in my eyes prompted by many personal factors, it must also be said that my mother stands in a long line of painter-travelers to the Middle East that dates back to a time before the advent of photography. At one time, the simple and effective technique of watercolor painting was used to record visual impressions. The ability to paint with watercolors was a common tool. For my mother, a watercolor class during her undergraduate years at Occidental College in Los Angeles encouraged her in this age-old technique. She put it to use and found it the best means of recording sights and feelings encountered during her time in the

Middle East. She rarely used the technique during her adult years spent in California; watercolor painting was reserved for my mother's travel bag. Thus the paintings in this book should perhaps be seen first and foremost as the work of one twentieth-century painter-traveler.

As a child, it was hard for me to miss the fact that when my mother painted, it always meant going off somewhere quiet, away from the rest of us. In fact the act of painting precluded any interaction with other people, and usually found my mother alone in some remote and dramatic spot, perhaps on the curve of an unspoiled beach, or on a rocky ridge in the desert facing the unearthly mountains bordering the Red Sea. Sometimes the painted scene was one of architecture, but it was always architecture that spoke to the natural beauty of the setting: the monastery of Wadi Natrun in Egypt, the golden domes of old Jerusalem, the uniform whitewashed and blue-trimmed houses of Sidi Bou Said in Tunisia. In every setting, my mother's vantage point would be a solitary one.

Over the years, the paintings began to cover the walls of our house in California, because my mother missed her life in the Middle East so much. My brothers and I shared the same favorites. Ironically, they include my mother's only set of scenes of human habitation and clutter. They were scenes from our apartment in the Ain Mreisseh district of Beirut in 1965–66, the year my second baby brother made his entrance into the world. For my mother it was a difficult year, saddled with three young children and a touch of post-partum blues, cooped up in a small apartment. But there were views from every window and she painted them all: the bay and beautiful arched windows of old houses opposite, mountains in the distance, and then our most cherished: the TV antennae-strewn apartment buildings across the street and the twenty-four-hour-a-day stream of traffic and pedestrian shoppers below my bedroom window. I remember the noise of honking horns and the glare of neon lights keeping me awake at night, until it was time to get up, put on my uniform, and catch the bus across the way that would take my brother and me off to our Franciscan nuns' school. This would allow my mother a bit of solitude, especially when our beloved nanny, Najeebe, would arrive for a few

hours, ready to scoop up the baby and cook a delicious Lebanese meal for us to come home to later on.

Those years in the Middle East were family years, brought to a sudden end when my father found himself in the wrong place at the wrong time. From then on our individual memories and sentiments for the place splintered, for the Middle East was inextricably linked with something each of us had lost but which no one else could quite understand. My determined mother, never rejecting the land that had taken my father from us, built up a new life for herself in Cairo. She kept painting, continuing a personal diary of a much-loved place and of changing times.

Preface

This is the story of a small collection of watercolor paintings I have done over several decades in the Middle East and North Africa and the history that goes with them. They are an expression of my affection and fascination for that part of the world. Each watercolor has a story—when and where it was painted, how I came to paint it, what was happening at the time, and what has occurred since. They evoke memories that go back and forth in time—memories that are a reminder that the present is always changing.

Each watercolor also has a story of what happened to it as an object after it was painted. These paintings have traveled half the globe, survived war, earthquake, fire, time, and neglect. Some are favorites and have hung in places of honor in the houses where we have lived; others have been stored away under the bed. Many of them currently hang on the walls of my home in California and help to shrink the distance between the Mediterranean near which they were painted and the Pacific on which I look out. As a collection, they are a documentation of an individual experience in the Middle East over a period of time as reflected through my particular prism on the world. We each paint our lives and frame our experiences of the world in a distinctive way for reasons that we cannot always understand. My paintings reveal a romantic view of the Arab world that has remained with me since I first went there almost a half a century ago. They do not reflect the terrible problems during the time that I described at length in my earlier book, *Come with Me from*

Lebanon. They are perhaps a way of escaping them and painting the Middle East I wanted to see.

Ann Zwicker Kerr

Pacific Palisades, California
September 2001

Acknowledgments

I would like to gratefully acknowledge the help of many friends and colleagues who have discussed ideas for this book with me as I have worked on it over the past several years. In particular I would like to thank those who critically read the first completed version of the manuscript and gave thoughtful ideas for its revision. Among those are Caroline Williams, Bill and Ulla Carter, Heghnar Zeitlian Wattenpaugh, Afaf Lutfi al-Sayyid-Marsot, Frances Khirallah Noble, and Naomi Shihab Nye.

Additional thanks go to Katherine Hales for her help in making the mosaic plaque and to three graduate students in Near East Studies who have worked in my office at UCLA and helped me with computer mechanics, editing, and ideas: Heidi Rutz, Patricia Singleton, and Lorraine Pratt. I would like to express my sincere appreciation to two editors at Syracuse University Press, Cynthia Maude, who arranged the initial contract, and Mary Selden Evans, who has shepherded the book through to its publication.

Randy Young spent untold hours photographing most of the artwork; without his help, the book could not have been completed. Francis Dzikowski at the American University in Cairo photographed the four paintings I had given to friends in Cairo, and Nick Griffin snapped the two photos of me painting Egypt.

Finally, I would like to thank my daughter, Susan Kerr van de Ven, for writing the foreword. Her keen comments about the content of the book as I was writing it and her final editing were invaluable.

Painting the Middle East

1

Painting as a Pastime

Painting is a companion with whom one may
hope to walk a great part of life's journey.
WINSTON CHURCHILL

I have always loved to paint with watercolors in the
Middle East, to try to capture the elusive moving sail of
a felucca on the Nile, the spires of minarets and palm
trees, the villages, and the duochromatic shades of
desert and sky and sea. It has been a way of becoming
part of a land I have loved well, of losing myself in try-
ing to capture it for an hour or two of absorption in the
scene I am painting. These paintings are not numerous,
for I do not paint often. Painting is not my profession
nor even the recreational activity I choose first. It is like
a special dessert that one prepares and indulges in only
occasionally but which brings delicious pleasure, in the
preparation as much as the eating. It is a way too of cap-
turing a place and a time, and if one likes the results, the
painting becomes a lasting souvenir with its own special
story and memories.

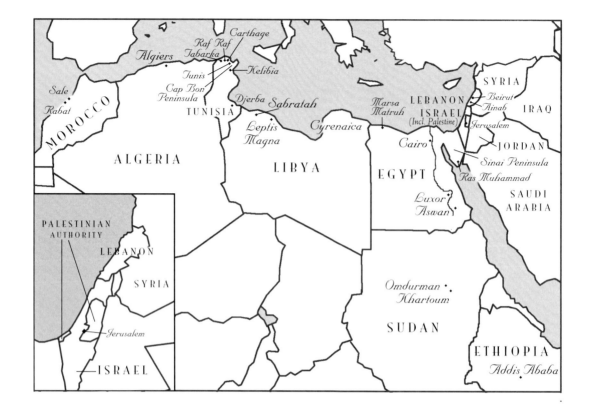

Painting is something I have done in the Middle East more than in my own country. I fell in love with that region in 1954 when I went as a student from Occidental College in southern California for a junior year abroad to the American University of Beirut (AUB), Lebanon. In that same year I also fell in love with my future husband, Malcolm Kerr, a young Middle East scholar doing graduate work at AUB, whose parents had been teaching there since the late 1920s. It was not until my next sojourn in Lebanon, as a young wife and mother, that I began painting. In my senior year at Occidental College I had taken a class in watercolor painting that stirred an artistic impulse. I learned to love seeing the swirling of colored pigment with water on the finely textured paper and sitting out of doors trying to capture a landscape.

We painted the old Victorian homes of Pasadena and the used car lots of Eagle Rock, yet after that class I rarely painted in my own country. For reasons about which I can only guess, my desire to paint emerged when I was in the Arab world much more than it ever did at home.

Intermittent journeys to the Middle East were part of my husband's and my life. As a scholar of the region and a professor of political science at UCLA, Malcolm had frequent leaves of absence to study there. As an informal student of the Middle East I relished every opportunity to be there and to have our children know the land to which their parents and grandparents were so attached. Whenever the opportunity arose, we took a sabbatical or a leave of absence to return to the Arab world.

I relished those times as chances temporarily to shed ourselves of possessions, civic responsibilities, and Malcolm's professional duties. We flew off with our children to share new adventures and challenges. For me, they also offered some freedom from housekeeping chores, thanks to the availability of household help. Surely this freedom was part of what made me want to paint the Middle East—along with a visceral attraction to the area that defies any logical explanation.

The Middle East was very paintable, with its pastel colors and domed mosques with minarets and palm trees spiraling into the sky. I felt the echoes of history while sitting lost in absorption on the Mount of Olives painting the old walled city of Jerusalem or observing the timelessness of feluccas sailing on the Nile with the sunlight constantly shifting on their sails. According to *Painting as a Pastime*,[1] a little monograph he published in 1950, Winston Churchill concurs on the advantages of painting and traveling: "There is re-

1. All quotations by Churchill in this book are drawn from his monograph of 1948, *Painting as a Pastime*, first published by McGraw Hill in 1950 and reprinted in 1965 (New York: Cornerstone Library Publications).

ally nothing like it. Every day and all day is provided with its expedition and its occupation—cheap, attainable, innocent, absorbing, recuperative. The vain racket of the tourist gives place to the calm enjoyment of the philosopher, intensified by an enthralling sense of action and endeavour."

There is a meditative quality about painting, engendered by the process of sitting out of doors and observing a scene with great concentration for a period of time. When we take time to contemplate the world we inhabit, we can become overwhelmed with awe for the Creator and for the divine spark that is evident all around us. It is possible, if real absorption happens, to feel a unity with nature and the universe and the process of creation that brings one boldly close to God—and the impossible task of attempting to re-create what has already been created with such unique artistry. And then the realization comes that we human beings are interpreters or impressionists in how we react to the world around us, part of the spontaneity of creation—the continually moving process of one element reacting to another in an unending chain of possibilities. The results of the painting may or may not be pleasing to the viewer but the minutes and hours the painter spends in the process of concentration on a chosen subject is time spent in union with creation.

This awareness of the mystery of creation can also strike the painterly mind in the tasks of everyday life. For me it can happen in cutting a peach and discovering the inner circle of red stamen around the ridged brown pit or rocking a new grandchild and seeing the grasp of its miniature fingers around one of mine. From these the artist can paint mental pictures, as she can also by observing the light on a given object as it changes throughout the day or the fleeting facial expression of a friend or loved one. The painter's eye can place an imaginary frame around a portion of an expansive view or create a still life from a corner of the living room. With artistic license in either imaginary or real paintings one can leave out unwanted objects or move things around to improve the composition, creating the image one wants to see.

And so it is that I have painted the Middle East over the last forty years—

on paper or in my mind's eye. Artistic license and a romantic view of the world have permitted me to retain in my watercolors my own innocence and, relatively speaking, that of the Middle East when I formed my first impressions there on my arrival in the mid-1950s. It should be added that lack of technical skill also played a part here, and I can again quote Churchill for support: "Even if you are only a poor painter you can feel the influence of the scene, guiding your brush, selecting the tubes you squeeze onto the palette. Even if you cannot portray it as you see it, you feel it, you admire it, you remember it forever."

Unlike Churchill who painted in both oils and watercolors, I have never painted in any medium but watercolor. Oil paint seems stiff and inflexible compared to the lightness of watercolor. For me it is enticing to touch my brush to a dab of watercolor paint, perhaps mixing more than one color to try and get the right shade, then dipping the brush in enough water, but not too much, to get the right tone. Then there is the pleasure of watching the colors touch the paper, particularly if the paper is of very good, heavy quality. The paint, the water, and the paper have a way of doing things together beyond that which the painter imposes on them.

I suppose a very experienced watercolorist develops more and more mastery over the materials, but my personal taste is for less technically perfect watercolor paintings where the impulses of the artist and the play of the materials are in evidence. While I would like to gain technical proficiency, I would not want my paintings to look photographic or stylized. A simple, direct impression with just enough lines to define the subject is my goal. With color, one can be a little more extravagant and look into all the different colors that make a green tree or a blue sea, but still simplicity is my guiding rule.

The Middle East I have painted has been an aesthetic rendering with perhaps some cultural or historic value but has had nothing to do with world events or the politics that were so much a part of our lives when we lived there. These paintings do not reflect the tensions between sectarian groups in

Lebanon nor the Arab-Israeli wars with their Cold War, superpower overtones that brought such disaster to the region and to our family. I did not paint on paper the major life-and-death events that affected us—the tragic civil war in Lebanon and the subsequent Israeli invasion, the exodus of Yasser Arafat and Palestinian activists from Beirut just as my husband was arriving to assume the presidency of AUB. I did not paint his inauguration as president in the university chapel with our two older children present, or, little more than a year later in 1984, his assassination outside his office and the memorial service in the same chapel. Those events are painted in my mind. My watercolors are almost the antithesis of such events. They represent hours snatched away from the business of everyday life—periods of time spent in nature amidst the sun-washed relics of the past where evidence of old cruelties and folly has faded away or been covered with sand and weeds.

2

Lebanon

May there be abundance of grain on the earth, growing thick
even on the hilltops; may its fruit flourish like Lebanon.

PSALM 72:16

The first paintings I did in the Middle East were in the village of Ainab in the mountains of Lebanon where my mother- and father-in-law had a small cottage. They and four other AUB families had found an idyllic hilltop high above the Mediterranean in the early 1930s and built simple stone houses there to escape the hot, sticky Beirut summers. Set in a forest of umbrella pines, our house was designed like the traditional houses in the village with stone archways leading into a front porch and windows with heavy wooden shutters. Ainab inspired people to paint. The stream of summer days and the fragrance of warm sun on pine needles in soft breezes invited one to sit outside with paintbrush in hand. I caught the interest from my father-in-law, Stanley Kerr, who painted a watercolor of the house he and his wife Elsa had built.

Stanley Kerr's painting of our Ainab house, c. 1950s

In the summer of 1959, Malcolm and I were living in Ainab with his parents and our baby daughter, Susie.

Our days were leisurely, spent mostly out of doors under the pines, on a big terrace that was also the roof of the cistern where winter rains collected for our summer water supply. Malcolm and his father took turns pumping the water into a tank in the kitchen near the shelf where the oil lamps were stored. Each morning a boy from the village came up the hill on his donkey to bring us fresh bread and yogurt and some fruits and vegetables to add to the supplies we brought up from our once-a-week visits to Beirut. With the help of a young woman from the village, my mother-in-law produced delectable Lebanese lunches served in our outdoor dining room, on another terrace with a view of the slopes of pines leading down to my father-in-law's vineyard.

I started with these geraniums which grew at the end of the terrace where

we spent much of our time. The bright red color of the flowers and velvety green of the leaves contrasted with the brown pine needles forming the carpet of the pine woods around us. They were in constant danger of being lopped off by Susie as she sped by in her walker. And so was my painting as I sat in attempted absorption, trying to capture first a realistic and then an abstract version of this lovely flower. Malcolm took this photograph of me painting in one of those moments when absorption was made possible by the fact that Susie was sleeping, judging by the empty walker in the background.

When Susie napped I could go further afield, taking my paints to the vineyard Stanley Kerr had created on a hillside sloping down to a valley, beyond which lay the coastal plain and a strip of blue sea. Here he loved to cultivate his grapes and fruit trees and experiment with grafting to produce new varieties of fruit. Wild flowers popped out between the rocks of the terraced

Geraniums in Ainab, 1959

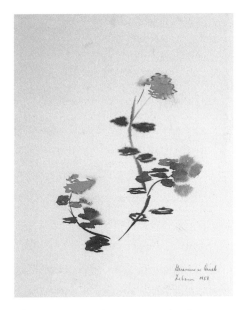

Abstract painting of geraniums in Ainab, 1959

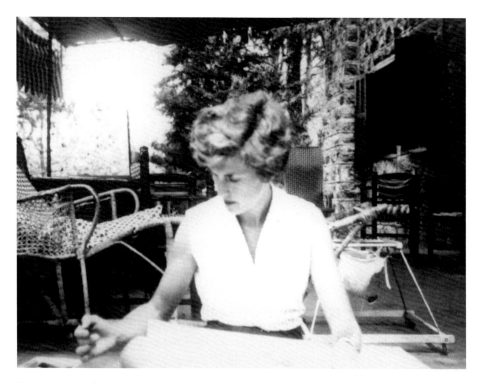

Painting in Ainab, 1959

hillside, an array of pink cyclamen, red poppies, miniature white daisies, and many other varieties. I sat for long periods of time in the warm sun, engrossed in trying to capture the delicate design of the grape leaves with their fine veins and curvaceous shapes and the blackish purple color of the grapes. For Lebanese, the leaves are as important as the grapes; one of their favorite dishes is *wara einab*, or grape leaves stuffed with rice, ground meat, onions, and garlic. But I could hardly think of these grapes or their leaves as edible as I sat contemplating the gracefulness and variety of their form. After long periods of concentration on every vein and nuance of color, I liked to try a quick ab-stract version of the intense study I had been making, which also used up the remaining paint on my palette.

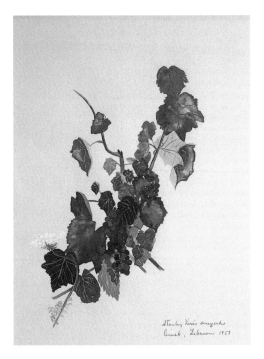

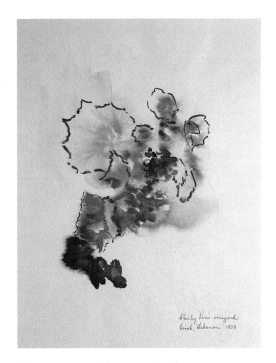

Grapes in Ainab, 1959 *Abstract painting of grapes in Ainab, 1959*

These times of painting in the vineyard were not frequent because of the demands of motherhood, but I learned from them the value of time away by myself as a counterbalance to the fragmentation of attention and energy that family life requires and to my natural preference for sociability over solitude. To concentrate on one scene or object in nature without another human being present stills the soul and taps resources that we can discover only when we are alone. I could lose myself in absorption with nature and feel creativity springing from within my soul.

I was reminded of the verse from the Sermon on the Mount: "Consider the lilies, how they grow; they neither toil nor spin; yet I tell you not even Solomon in all his glory was arrayed like one of these." (Matt. 6:28; Luke 12:27). I like to think that the flowers that surely popped up all over the bib-

lical land of Lebanon inspired this verse. The descendants of these biblical flowers still covered the mountains in profusion when I first discovered Lebanon, but each time I returned the intrusion of cement, in the form of high-rises and new roads into the mountains, had diminished the land where flowers could grow. Then during the seventeen years of civil war, they popped up again amidst the ruins—red poppies, anemones, and cyclamen reclaiming the land. Since the war, cement again has overtaken the flowers, blighting the land in a way far different from the war's damage.

The next paintings I did in Lebanon were painted six years after the Ainab paintings when we had returned there on sabbatical leave from UCLA in the academic year of 1965–66. We lived in the seaside quarter of Ain Mreisseh, a poor but picturesque neighborhood just below the AUB campus. As in Ainab, the scenes from our Ain Mreisseh apartment invited one to paint, and I found great variety merely by going out on our different balconies. The seaside, in all its shades of blue, gray, green, and turquoise, was peaceful and conducive to contemplation, looking across the little fishing bay to lovely old nineteenth-century houses with red tile roofs and arcaded balconies. Just beyond was the Beirut harbor while Mt. Saneen rose in the far distance, changing from blue to purple hues and in the winter capped with snow.

This peaceful view from our front balcony was almost a classic scene of Ain Mreisseh. Everyone in Beirut who liked to paint had painted it; tourists liked to photograph it; and we were lucky enough to see it from our living room and bedroom windows. We got used to sleeping to the sound of the sea lapping against the shore at night. Occasionally, when the water became completely still, the lack of noise would wake us up even more than the crashing of a loud storm.

I painted the bay from our front balcony many times trying to capture the changing light on the water and the antique houses. These lovely buildings were the heritage of the previous century. Part French colonial, part Mediter-

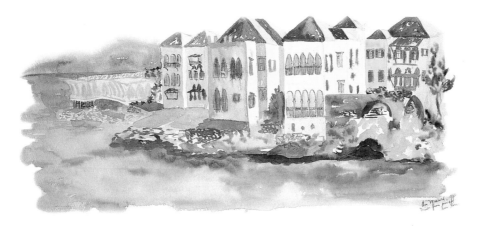

Ain Mreisseh Bay, 1966

ranean Arab in style, they give Lebanon a distinctive architectural flavor with their arched balconies and windows, decorative wrought iron, and red tile roofs. I left out of my paintings what I did not want to see—the cement block high-rises looming over the red tile roofs and occasional black swirls of sewage seeping into the sea from pipes that were no longer adequate because of all the recent overbuilding. The low, modern white arcaded building at the end of the row of old houses had been built a few years earlier and became a well-known landmark in Beirut, the Artisan, a government-sponsored center where artists displayed their work and Lebanese handicrafts were sold. During the war heavy fighting in Ain Mreisseh left the Artisan an empty shell, but the steel arches held and stood defiantly throughout the war. Since the war the building has been taken over by a Lebanese entrepreneur and turned into a rather lavish restaurant with the archways still intact.

The street side of our apartment, in great contrast to the sea side, was bustling and jarring with the noise of traffic competing with the call to prayer blaring from the loudspeaker of the mosque next door. My palette called for

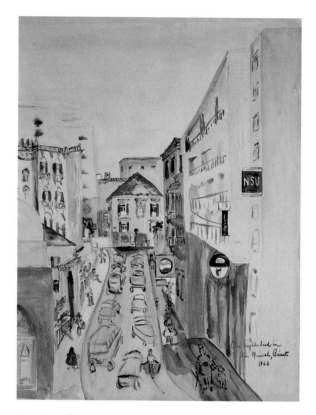

Ain Mreisseh street, 1966

the burnt siennas and warm beiges of Mediterranean architecture, with splashes of color added by the street signs and by the dark green shutters and red tile roofs of the older buildings. There was always lively activity to observe, and the colorful street scenes made me want to sketch people in my usually peopleless landscapes.

These were figures I saw frequently in our small Muslim quarter of Ain Mreisseh. Here is a grandfather, wearing the tarboosh and billowy trousers of an earlier generation, walking his small grandson to school. A mother walks

past the mosque with her child, wearing a black coat and head scarf that were not so common in the sixties but were to become more so among Muslims as Islamic conservatism took hold in the 1970s. The street vendors, one on a bicycle, another on a donkey, others walking, had a challenging job to call out their wares over the traffic noises. "Let me sharpen your knives and scissors," "Tomorrow, tomorrow, buy a ticket for tomorrow's lottery," "Shoe shine, shoe shine, only one pound for a shoe shine."

Adding to the atmosphere of the neighborhood was the smell of garlic and onions cooking in olive oil that wafted up to our apartment from the Spaghetteria Restaurant on the first floor of the building. It started far too early in the morning to be appealing, but when I was painting outside on the southern balcony later in the morning the aroma added a provocative ingredient to the process of trying to capture the life of the Ain Mreisseh quarter on the street below.

Directly across the busy street from our apartment was this elegant old house, built in a different era but now cluttered with the add-ons necessary to accommodate an increasingly crowded Beirut. One can only imagine what lay in front of the house before it became a parking lot. Tucked into the foundation are later additions in the form of two small shops, seen in the lower right portion of the painting. There is our neighbor Um Tony, in roughly sketched form, on her way to buy groceries from Michel and vegetables from Muhammad. Um Tony, a Christian in a predominantly Muslim neighborhood, never ceased to point out the differences between Michel's and Muhamad's families and the superiority of the Christians as exemplified in Michel's way of life.

Looking at this painting of the old house makes me remember how delicately beautiful it was, and yet how fragile. Surrounded by plainer, more modern buildings, it was a reminder of a more refined time in Beirut's social and architectural past—and perhaps in the world's. At night this relic of his-

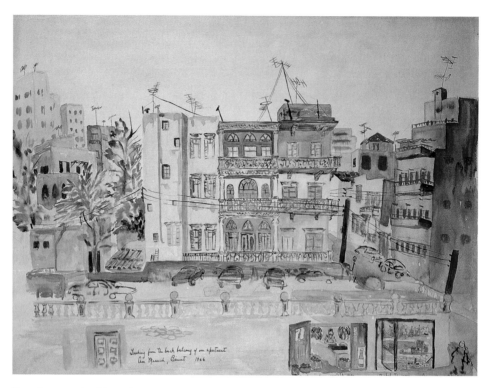

Beige house in Ain Mreisseh, 1966

tory became young again when lights were turned on inside by occupants unseen in the daytime, illuminating the arched windows and casting a warm glow into the night. The seediness of the building and the addition of parked cars and shops, so evident in the daytime, receded by night, and its fine design and good structure came into dominance. Sometimes I was tempted to exclude the recent protrusion of television antennae from my paintings, but in this particular scene, the aerials seem to underscore the encroachment of time on this intriguing old building.

Down the street from our house, in the opposite direction from the painting of the street scene, was a small alleyway which we passed as we walked to-

ward the AUB campus. The alley was an inviting retreat from the clamor and noise of the street and had not yet been invaded by modern buildings. In order to paint this scene I chose a mid-morning after the pedestrian traffic of children being delivered to school had abated and when our nanny, Najeebe, could watch the baby. Armed with my paints, a Frisbee for a palette, brushes, paper, a large-sized Nescafé jar of water, and a small stool, I established myself at the entrance to the alley near the street and attempted to assume the state of concentration necessary to paint. This required ignoring not only the traffic noises but the curious and sometimes intrusive behavior of passers-by.

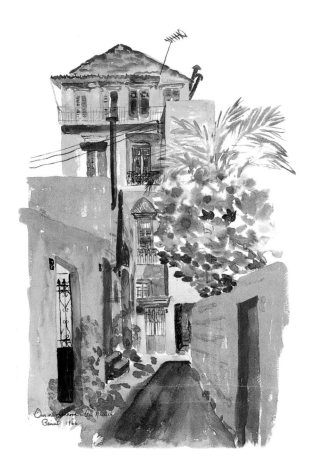

Ain Mreisseh alleyway, 1966

I learned to assume a stony-faced silence as a way to ward off advances, verbal and otherwise, a tactic that succeeded sometimes better than others. My stony face did nothing to ward off the flies, however, which swirled around the piles of garbage in the street and then came over to visit me. In my paintings the garbage problem was easier to solve; I just left it out.

The midmorning sun filtered through the palm and orange trees, casting dappled shadows on the opposite wall. As I sat gazing at the tall building at the end of the alley, I discovered that the five floors were all different, each one added perhaps as a son married and brought home his wife, or a brother or sister came to live here. The distinctive wrought-iron balconies, more decorative than practical, were used mainly as places where women called out their vegetable orders to the street vendors and lowered baskets down on a rope to pull up their purchases. The inviting atmosphere of the alley is contradicted by all the closed gates and shutters; only the wrought-iron gate on the left is ajar.

Further down the Ain Mreisseh street from our apartment, on the way to the AUB campus, was a fishing cove that fit the artist's expectation of what a Mediterranean fishing cove should look like. It remained relatively unspoiled when I painted it in the late spring of 1966.

Here is the vibrancy of life in Ain Mreisseh—the sunny beiges of the Mediterranean architecture, the sparkling blue-green shades of the sea, the fisherman working with his nets, the boats waiting for their next fishing expedition, the casual onlookers observing the scene below, the two women chatting on their balcony, perhaps waiting for a grocery delivery, the vendor relaxing on his empty cart after the vegetables have been sold, and the little Volkswagen bug that was popular at the time and more suited to narrow Beirut streets than the big American sedans that many people preferred.

When the civil war started in 1975, Ain Mreisseh became an area of heavy Muslim-Christian fighting and many of its inhabitants moved elsewhere. The civil war dragged on, with periods of quiet when it seemed that all

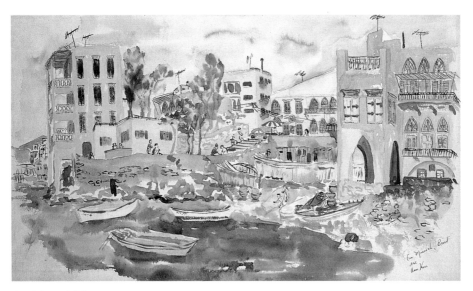

Ain Mreisseh fishing cove, 1966

the possible sectarian and religious groups in Lebanon had fought each other and at last the fighting would stop, but the web was so complex that a ripple from Arab-Israeli or Cold War entanglements could set things off again. Hope sprang eternal among the Lebanese, however, and with Malcolm and me as well; when he was asked to be the president of AUB in 1982, we were willing to believe that the war had almost spent itself.

By the time I saw Ain Mreisseh again in 1998, nearly fourteen years had elapsed since my last wartime visit to Beirut in 1985. The area was almost unrecognizable—not from war damage, but from construction. The graceful old buildings on the sea that we had looked at from our balcony had been torn down to make way for tasteless new buildings and to accommodate a causeway through the little bay in front of our apartment. The fishing cove that I had painted in 1966 was partially preserved, with a passage under the causeway allowing access for sea water. The small boats were docked by the boathouse in what looked more like a backwash than a fishing cove, but gaz-

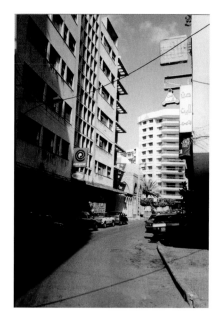

Ain Mreisseh street, 1998

Beige house in Ain Mreisseh, 1998

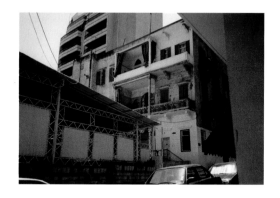

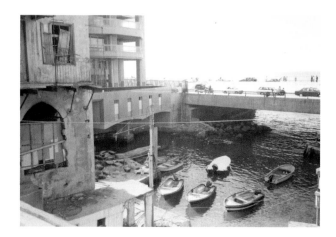

Ain Mreisseh fishing cove, 1966

ing out to the causeway over the water tunnel I could see that the area was being enjoyed in a new way. The sidewalk was full of people strolling and enjoying the sea breezes. Most of them were probably unaware of the quaint fishing cove that had been a landmark in Ain Mreisseh for so many years.

The alleyway with the walled gardens and the old traditional house at the end was gone, but our apartment building was intact except for a few shell holes and the Spaghetteria Restaurant was still functioning. The mosque and the palm tree next door were in place, and I even found the NSU sign of an insurance company—appearing in bright red and blue in the upper left corner of the Ain Mreisseh Street painting—now faded out and colorless. The house at the end of the street with the red tile roof had been replaced by an eleven-story apartment building and there were no more donkeys and carts or old gentlemen in red tarbooshes. The cars were distinctly more modern, and I discovered that further down the street was a McDonald's with valet parking.

One important building that needs to be included in this Beirut collection is one I painted later than the other paintings. That is College Hall, the central building on the AUB campus and one of the three original buildings begun in 1871, five years after the founding of the university in 1866. Over the years, it has served different functions at different times, housing classrooms, dorm rooms, the library, administrative offices, and the president's office.

Daniel Bliss, the first president of AUB, wrote about completing the construction of the original College Hall in his 1920 memoirs, *The Reminiscences of Daniel Bliss* (London and Edinburgh: F. H. Revell). "On March 13, 1874, we accomplished the risky task of hoisting the bell to the College Hall tower. The students pulled well at the rope and the Faculty were summoned to join them to hear the bell rung for the first time at five P.M." The bell continued to ring through the decades and the clock tower and College Hall became the heart of the university and the symbol of AUB. When Malcolm was assassinated outside the president's office in College Hall on January 18, 1984, I thought the bells would surely stop ringing. But they did not.

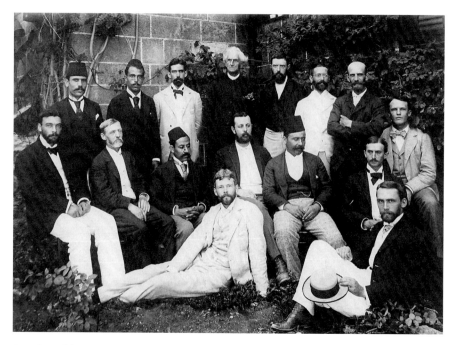

President of the American University of Beirut Daniel Bliss (back row, fourth from left) and colleagues in front of the original College Hall, c. 1893.

College Hall and AUB stayed in operation throughout the civil war with interruptions that were sometimes longer than others. When the building was blown up in 1991, in one of the last suicide bombings of the war, the chimes that had rung out the hours for more than a hundred years were silenced.

Within hours the call to rebuild came from alumni and friends of AUB around the world. Perhaps the perpetrators of the bombing had known that a grand celebration of the 135th anniversary of the university would be taking place at the Waldorf Astoria Hotel in New York City the next day, with hundreds of AUB supporters present. What they could not know was that the act

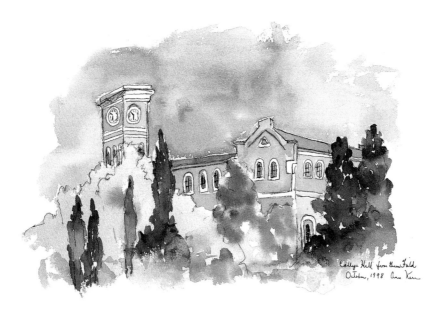

College Hall, 1998

they perpetrated would become the rallying point for launching the rebuilding of College Hall.

I was able paint this hasty watercolor of the newly completed College Hall on a hot early October day in 1998. Absorption with the subject I was painting made me forget the heat as I sat under some low trees by the athletic field looking up a terraced hillside at this close replica of the original. From this distance it was hard to see much difference between this building and the one that Daniel Bliss and his colleagues had planned and inaugurated. As I painted, I glanced up occasionally to observe the local scene on the athletic field—so different from earlier years. A group of mentally handicapped children was being led in exercises by their teacher. Male and female joggers of different ages circled in their sweatpants and T-shirts. One woman wore an Islamic headdress and sweatsuit, looking uncomfortably hot but persevering.

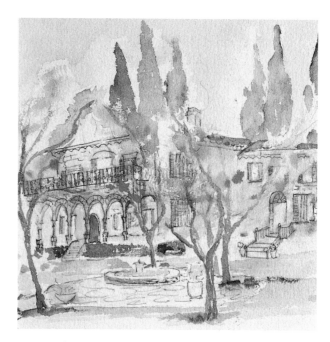

Marquand House, 1999

I, too, persevered, not particulary enchanted with the results I was getting, but happy to have the chance to sit there and have a new College Hall to paint.

There was another important scene missing from my earlier Beirut paintings, the beautiful campus residence of the AUB president that was our home for a short time in 1983 and 1984. Here is a quick rendering of Marquand House which I painted on a brief visit to Beirut in 1999, working in a far corner of the garden under a canopy of jacaranda trees.

In 1877 an American philanthropist, Mr. Frederick Marquand, donated $5,000 to build a home for the president of the university. It was finally completed and occupied by the Bliss family in 1880 and then by successive presidents over the years with occasional interruptions. During World War II Stanley Kerr spent some time in one of the upstairs bedrooms when he came

Marquand House, drawn from 1920 photograph for Christmas card, 1983

back from the United States in 1941 after leaving his family in Princeton to wait out the war there. We too lived in Marquand House during wartime and defiantly refurbished it to make it seem like home. I decorated it with some of my watercolors and old photographs of Mark Twain and Teddy Roosevelt, which Malcolm had found in an upstairs closet. They had been among the distinguished guests who had visited Marquand House over the years.

I drew this picture of Marquand House for our Christmas card in 1983, the one Christmas we spent there, from a photograph taken outside the entry gate in 1920.

This remarkable postcard photograph of the upper campus of AUB (then Syrian Protestant College) shows a side view of Marquand House and College Hall in about 1907, not too long after the time Roosevelt and Twain would have visited. The postcard was produced by Bonfils, a prominent French photographic business in Beirut, and was discovered by a friend in an

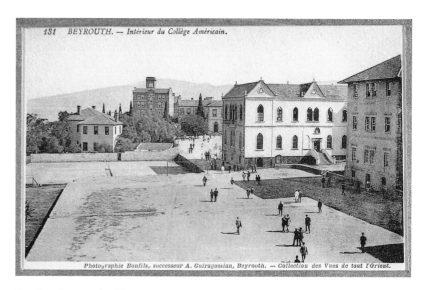

Bonfils's photograph of Beirut campus, c. 1907

antique shop in the Catskill Mountains in New York a few years ago. The cypress and pine trees in the postcard photograph now tower over the buildings, and other trees and flowers have been planted, creating a park-like setting. The AUB campus, unlike other parts of Beirut, seems to transcend time. It is almost as beautiful as it was when I first saw it and has remained a haven of relative tranquility in the war and postwar years.

3

North Africa

In the watercolor on the balcony, I seized Africa for the first time.

PAUL KLEE *on seeing his first view of Sidi Bou Said*

While the greatest amount of time I spent in the Arab world was in Lebanon and Egypt, the watercolors that are most numerous on the walls of my house are from North Africa. In the summer of 1971, at the end of a family sabbatical in France, we drove across North Africa to Tunisia, where we spent three months near ancient Carthage. Somehow all the conditions for painting seemed right that summer and I was pulled into it as I had never been before. The air was balmy after a cold French winter and the Moorish architecture set against the seascapes of the Mediterranean coast very appealing. The colors of Tunisia were the airy, pastel tones of watercolors, and everywhere I looked there was a picture waiting to be painted. One of my favorite scenes was this classic North African house beside the Punic ports just up the street from where we lived.

I found a good place to sit on a promontory between the two small ports, one that had been used for commercial and the other for military ships, where bits of Carthaginian and Roman columns poked out of the ground waiting to be excavated. In this setting, it was easy to conjure up images of the ancient Phoenicians sailing from what is present-day Lebanon to trade along the North African coast. They made a permanent settlement at Carthage in 814–813 B.C., sailing their small ships in and out of these ports. The gleaming white house on the shore intrigued me and I painted it many times that summer, memorizing all those sharp, square angles that gave way to the smooth,

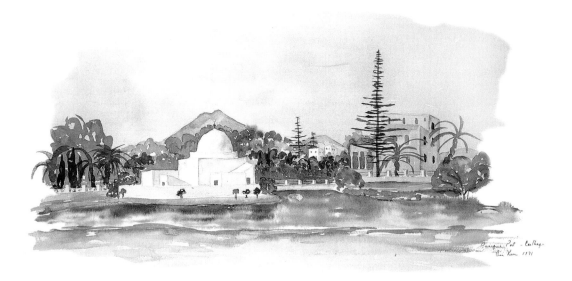

Domed white house by the Punic port, 1971

rounded line of the domed roof with Mt. Abu Kornine in the background. The neighborhood was so quiet that I had little idea of the life of its inhabitants. The stillness was broken only occasionally when the faint noise of a baby crying came from the Moorish house, but otherwise I had little sense of what was going on around me.

When I felt like painting a different scene, all I had to do was turn around and face the other of the two Punic ports. From the same spot on the promontory I could look in the opposite direction at this tall white house beside the Bay of Tunis and beyond to the open sea.

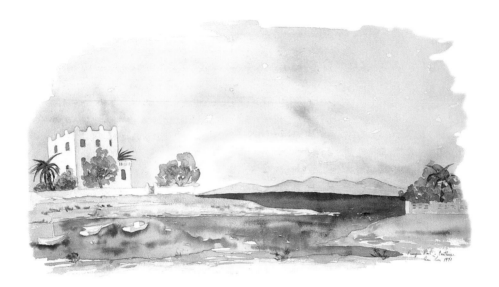

Large Tunisian house overlooking the Bay of Tunis, 1971

The house we rented that summer was on Rue Hannibal, named after the famous Carthaginian general who led campaigns against the Romans in the second century B.C. with elephants in his battalions. The house was white with blue trim, the traditional colors of Tunisia. The sleepy little neighborhood was full of history. In many of the gardens around us, we could see old Roman capitals and columns used as decor, dragged in from some nearby historic temple site. As we walked along the unpaved sidewalks we learned to watch for loose tesserae, the small cubed stones used to make mosaics. They

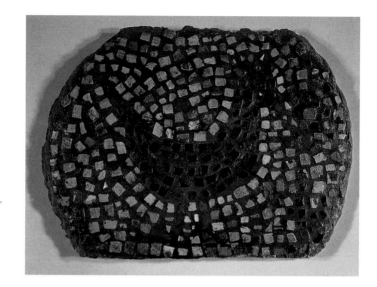

Mosaic plaque made by the author
from Carthaginian tesserae, 2001

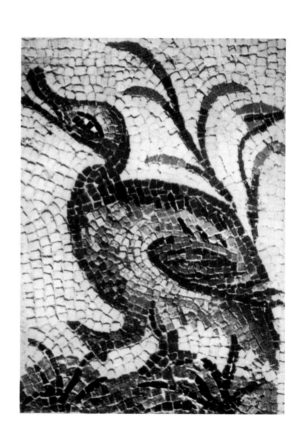

Third-century mosaic from El Djem
in the Bardo Museum, 2001

were in great abundance, left over from the grand mosaic floors that had been part of Carthaginian and Roman houses. Just walking down the street became a treasure hunt. It seemed miraculous that we could have this tangible contact with the lives of people who had lived here so long ago.

I brought home a box full of these small cut stones to re-create my own mosaic to have in California. Most of the tesserae had lost their color, but with the help of a friend, I tried to create a mosaic plaque for my garden that reminded me of the mosaics of the ancient Mediterranean world. Lacking the talent and the raw materials of the Carthaginian craftsmen, our end product did not match the quality of the perky duck that was our inspiration (see photograph). But I know that peeking from behind my rose bushes are remnants of mosaics from houses that existed almost two thousand years ago.

One of the pleasures of our life in Tunisia in the summer of 1971 was exploring some of the pristine beaches along the western coast before the onslaught of tourist development had littered the coastline with cheaply constructed hotels. Our favorite was Raf Raf, about an hour's drive from Tunis and completely unspoiled at that time. The small village on a long, deserted beach epitomized Tunisia for me and already looked like a watercolor before I painted it. I caught this image of it on a day when all the circumstances for painting were inauspicious.

We arrived at Raf Raf on a late Sunday morning, three families with a total of ten children, in plenty of time for our picnic, we thought, before the strong afternoon winds started blowing off the Mediterranean—but the wind was already howling. We sought protection among some sand dunes, where we tried to get our sandwiches into our mouths between gusts of wind. Children, sand, food, dogs, wind, and onlookers were not my idea of the right circumstances for painting, but the scene was so enticing that I had to take out my

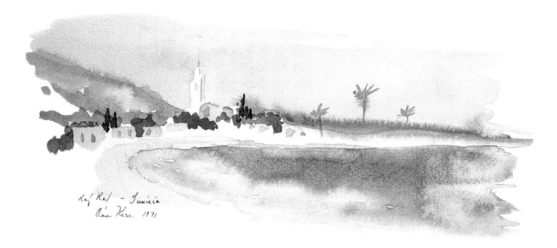

Village of Raf Raf, 1971

watercolors and try. As I painted, I consoled myself that the sand blowing into the paint and all over the paper would add texture to the painting, but, in fact, when it dried, the fine, white sand brushed right off.

Whether through inspiration or determination, this watercolor of Raf Raf emerged with some of the simplicity of line and color that I had been trying to achieve. Part of my inspiration that summer came from the work of a local Russian artist displayed in a small showcase along Avenue Bourghiba in downtown Tunis. I never met the artist, but I stopped to gaze at her work every time I went into Tunis. I still think of her when I look at this painting of Raf Raf and remember her signature, Galina.

◆　　◆　　◆

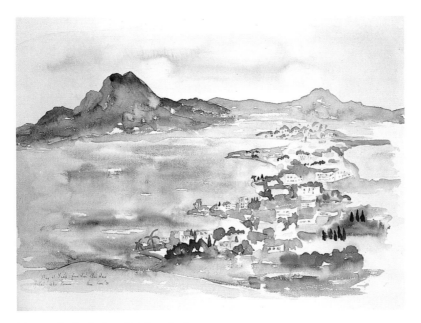

Tunis and suburbs from Sidi Bou Said, 1971

One of our favorite jaunts was to take the local train out to the scenic town of Sidi Bou Said. Sidi Bou Said was perched high on a hill stretching into the Mediterranean, on a promontory that looked north to the open sea or back to the more interesting view of the bay of Tunis with Mt. Abu Kornine rising over it. From there one could look off in the far distance to the city of Tunis and all the small suburbs that stretched out between there and Sidi Bou Said. I found a place on a pine-wooded hillside and painted this view of the layout of Tunis and its suburbs in the Carthage area.

On another day I painted a view of Sidi Bou Said from La Marsa, one of the small beach towns stretching along the open sea to the northwest.

This closer view of Sidi Bou Said was painted near the train stop where we got off to walk up the small narrow road through the maze of blue and white houses into the center of Sidi Bou Said. The painting shows the steep rise of hillside houses, which I unintentionally made to look more like high-rises

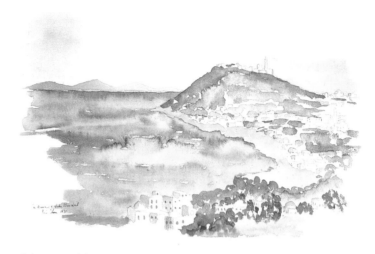

Sidi Bou Said from La Marsa, 1971

than the simple one or two-story square houses that are traditional in North Africa. Walking up through the narrow streets, we passed walled gardens with bougainvillea cascading over the tops. Jasmine grew in every garden, permeating the air with its fragrance. The sunlit white walls formed a palette

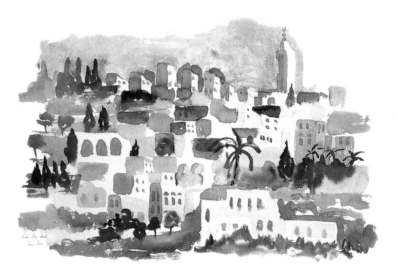

Houses of Sidi Bou Said from train stop, 1975

for the shadow of a nearby cypress tree or the bright sky-blue wooden doors and filigreed wrought iron windows that were traditional to Tunisia. There was an air of mystery as to what cool and fragrant haven lay behind those white walls.

In 1975 I had a chance to paint again in North Africa when Malcolm was asked to give a series of lectures in Tunisia, Algeria, and Morocco. Our first stop was Tunis. We stayed in the new ambassador's residence, which looked like a larger version of the domed white house by the Punic port that I had painted so often in Carthage. The balcony outside our bedroom faced directly toward Sidi Bou Said, enabling me to sit in great comfort, trying to recapture this beautiful town four years after we had first encountered it.

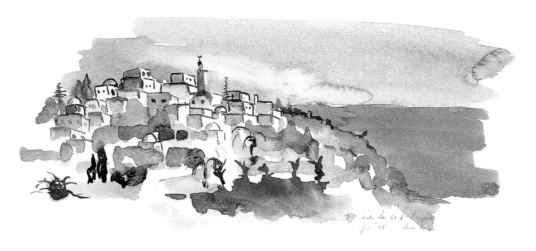

Sidi Bou Said from the American ambassador's residence, Carthage, 1975

From Tunisia we continued on to Algeria, where we stayed in another impressive ambassadorial residence. It was an old, ranging, two-story Ottoman palace with simple white walls and double arched windows surrounded by

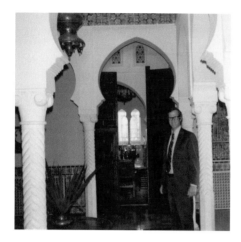

Malcolm Kerr standing by Islamic archways in the American ambassador's residence, Algiers, 1975

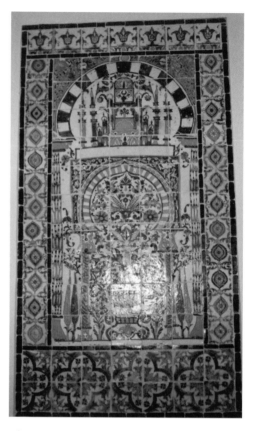

Close-up of tiles in the American ambassador's residence, Algiers, 1975

Close-up of tiles in the American ambassador's residence, Algiers, 1975

large gardens of palm, cypress, and pine trees. We were ushered into the house where the sound of Mozart was wafting incongruously through the high ceilings and ornate arabesque archways. Several intricately tiled sitting rooms were furnished with low white couches whose plainness left the eye free to turn to the highly decorated walls and ceilings.

From Tunisia we flew to Rabat, the capital of Morocco. This was a city we had never visited before, situated on the Atlantic north of Casablanca, where the Dutch freighter I had taken to Beirut in 1954 had docked for a day. The familiar Ottoman touches to the architectural landscape that we had known in other Arab countries were not present in Morocco. Moorish in flavor, Moroccan architecture was distinctive from that of other Arab Islamic countries. It lacked the overdecorated quality of Ottoman buildings and was more solid and square. Luminescent green tiles decorated the roofs of palaces, mosques, and shrines, contrasting handsomely with square white walls.

Rabat was an old walled fortress with a charming mix of Berber, Arab, and French culture, perched on a rise above the Atlantic. It was a small town and an easy place to get around. I was able to get out to paint with relative ease and discovered a perfect spot on the shore of an inlet off the Atlantic. There I

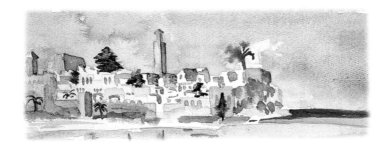

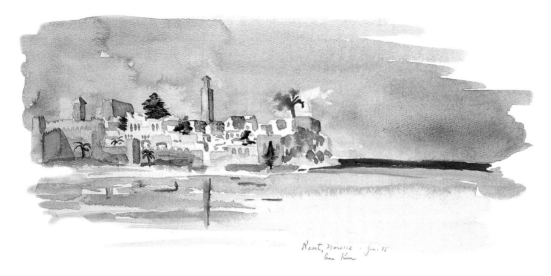

Rabat, 1975

could face either the old walled fortress town of Rabat or the town of Sale from where, we were told, Barbary pirates were well poised to sail into the Atlantic or the Mediterranean between the sixteenth and the nineteenth centuries.

I sat on the ground at that inlet for an entire morning, feeling pulled back into history, imagining the little fishing boats I was painting as pirate ships sailing away on adventures of pillage and wondering how many times the walls of Rabat had had to withstand attacks. At the dawn of the Christian era, Sale had been the westernmost outpost of the Romans in North Africa. Before that the Carthaginians had planted colonies along the coast, mingling with the local Berber population. I was free to indulge in flights of imagination as I sat in the bright winter sun, absorbed in trying to capture these scenes with my watercolors.

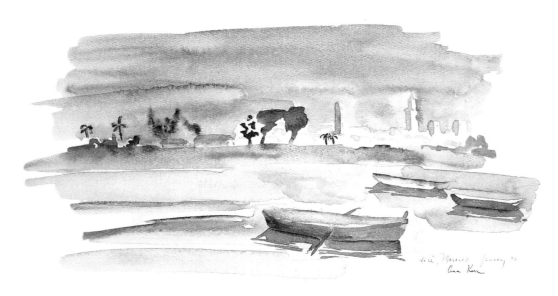

Sale, 1975

The warm beige tones of the stone walls of Rabat were reflected in the calm shallow water of the inlet, and beyond I could see a strip of deep blue Atlantic water. It was hard to comprehend that the Arab world stretched across such a large part of the globe, touching the Atlantic, the Mediterranean, the Red Sea, and the Indian Ocean. The city of Rabat took little notice of its ocean views, for it had been constructed over the centuries to protect itself from the outside world. The life of the city took place within its old fortress walls, which I soon discovered when I went walking there with friends.

These photographs bring back memories of having lunch in a restaurant tucked up against the inner walls of Rabat above the ocean. The top layer of the city wall was built with narrow openings between huge square blocks of stone, areas from which the defenders of the city could look out and position

With a friend in Rabat restaurant, 1975

Friends in Rabat restaurant, 1975

Kerr children grouped around Roman statue in Leptis Magna, 1977

their weapons to fight their enemies. Our table was positioned in front of one of the openings, allowing us to peek out at the waves washing up on the beach below. We were eating a delicious lamb stew baked with prunes, garlic, onions, and unfamiliar seasonings. Standing on the table was a bottle of Moroccan wine whose musty flavor was well suited to the ancient walls surrounding us.

In 1977, after a sabbatical year in Cairo with our four children, we again set out for Tunisia by car, this time from the opposite direction of our journey in 1971 from France. In an adventuresome plan we decided to drive across Libya to spend a month in our favorite country in North Africa. More foolhardy than knowledgeable, we set off with blankets to throw down on the beaches at night, a lot of canned mackerel imported to Egypt from China and a leaky jerry can of emergency gasoline. The beaches turned out to be too garbage-strewn to be tempting camping sites, so we opted for Libyan hotels. Despite the whopping prices we were charged, their dubious standards of cleanliness made us glad to have our own blankets to throw down over the beds. The chance to visit the ruins of cities from antiquity made up for the hardships of our food and accommodation. The Phoenician-founded cities of Cyrenia, Sabrata, and Leptis Magna, situated gloriously on well-chosen sites across the Mediterranean coast, were layered with the remnants of Greece and Rome. Restored by the Italians when they occupied Libya prior to World War II, these large, ancient cities had had few visitors since the war. We had the privilege of witnessing these places almost by ourselves in a country that did not welcome tourists. I captured the flavor of that trip with this photograph of our children perched around a Roman statue.

We reached the Tunisian border with a sense of relief to be in a welcoming and tourist-friendly country and treated ourselves to a few days in a hotel on the island of Jerba. According to legend, this was the place where Ulysses

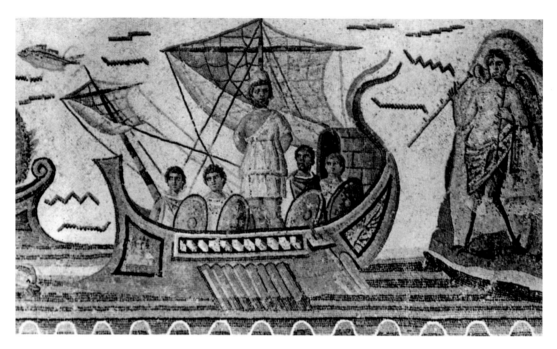

Mosaic of Ulysses and the Sirens from the Bardo Museum, 2001

was attracted by the sirens or sea nymphs who interrupted his journey, as seen in this mosaic from the Bardo Museum in Tunis.

From Jerba we proceeded north up the coast to the small fishing village of Kelibia on the peninsula of Cap Bon, the point of land seen across the Bay of Tunis in my painting of the large white house. American friends who had lived in Tunis for many years helped us find a small house for a month. They warned us that the house was very basic, but we assured them that that was just what we wanted. My romantic illusions of village life quickly vanished as I realized that just keeping enough food and drink in the house and preparing meals took up much of the day. Now, twenty-five years later, it is easy to forget the hardship and remember the opportunity we had to live close to the

Fishermen's bay in Kelibia, 1977

fishermen of Kelibia. I painted this scene of the small bay one morning after all the boats were back from the night's fishing.

After selling their fish, the fishermen would sleep until it was time for a late afternoon main meal and then make their preparations to go out to sea for another night's work. We became very familiar with the rhythm of their lives as we watched them from our veranda heading out to sea at dusk with their

Kerr children at Kelibia Bay, 1977

large floodlights glaring into the water to attract the fish. If we awoke early enough, we could hear the boats chugging back in again at dawn and, nearby at the port, the noise of early morning haggling with customers over the price of the fish. These sounds became the timekeepers of our days, and at dinner we ate the fish that they had caught the night before.

Looming over all of us in Kelibia, fishermen and summer visitors alike, was an old castle on top of a hill—a castle of little significance, apparently, because no one knew much about it, nor did it seem to have a name. It was safe to guess that any castle perched high up along the coast had probably

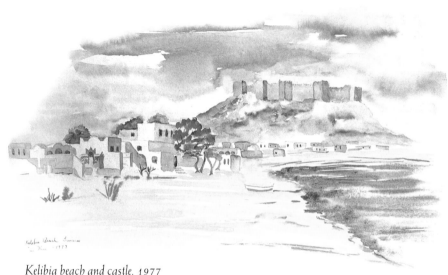

Kelibia beach and castle, 1977

been used for strategic purposes by successive rulers over the centuries—and perhaps by pirates too. The castle did not even look interesting enough to climb to, but it did make a nice addition to our view of the town and I wanted to paint the scene. Each time I set out to do so, something happened, but fi-

nally, on the last day of our stay, I went out to the beach to paint this view in a blustery wind, determined to capture a souvenir of our month in Kelibia.

This painting would make a better advertisement for Tunisian tourism than an accurate rendition of the run-down fishing village and the tar-spotted beach where we lived that summer. Amidst the fishermen's huts, which became charming white cottages in the painting, was our house, the second from the left with the low wall opening onto the beach. Behind the two-story white house was the Hotel la Florida, whose name we couldn't say without laughing. This was only a step up the comfort ladder from our rustic cottage, but we hoped it would be a suitable place for my parents when they came to see us at the end of our stay. Missing from my painting are the boys of all ages playing soccer on the beach with our boys, which is one of the favorite family memories of that summer. With this rendering of the Kelibia beach and castle, another romanticized painting of the Arab world was added to my collection.

Not too long ago, I had a Tunisian visitor about the age of my sons who is the head of a human rights organization in North Africa. When he told me he grew up in Kelibia, I showed him my painting. He was flabbergasted; "That's my house," he exclaimed, pointing to one of the white houses on the beach. "Did you live there in 1977?" I asked him. Not only did he live there in the summer of 1977, he remembered playing soccer with three American boys on the beach in front of his house!

At the end of our month in Kelibia came the long-awaited visit from my parents, who had always wanted to see Tunisia. Reluctant to expose them too quickly to the more rustic than romantic life we were leading in the fishing village, we made a plan for Steve and me to meet them in Tunis and let their first stopping place be Sidi Bou Said. We made a reservation in a hotel where Malcolm and I had always hoped to stay—a small converted palace in a garden full of bougainvillea and jasmine looking out on the Bay of Tunis, the Dar Zarouk.

The Dar Zarouk more than made up for the long and tiring trip my parents had made all the way from Los Angeles. We were enchanted with the white Moorish architecture, the balconies overlooking the sea, and the scent of jasmine in the warm summer air. I woke up the next morning before everyone else and painted this view. I remember the solitary pleasure of sitting on the

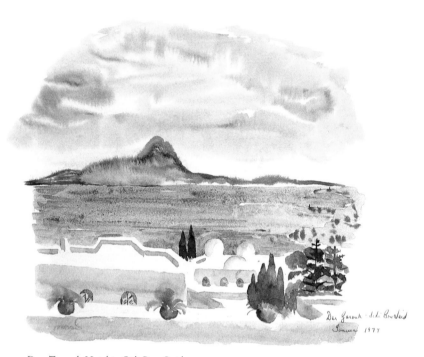

Dar Zarouk Hotel in Sidi Bou Said, 1977

balcony outside Steve's and my room in the early morning coolness and absorbing the blue and white beauty of Tunis. My parents had safely arrived after much planning and preparation, everyone was asleep, and I had an hour or two all to myself to become engrossed with my paints in the beauty around me.

I did not go back to Sidi Bou Said or Tunisia for sixteen years, and, when I did, the Dar Zarouk had changed from a beautifully appointed and maintained hotel to a rather uninspiring restaurant. That intervening decade and a half was a time of huge growth in the tourism industry in Tunisia, which may have been to the advantage of the economy but was detrimental to the charm and natural beauty of the country. In the summer of 1993, I took a group of ten high school students to Tunisia on a month's study tour for the National Council on U.S.-Arab Relations. I was by that time living back in California and working at UCLA, perhaps taking for granted the well-tended streets and homes of the west side of Los Angeles. The airy paintings of Tunisia hanging in my living room, plus a certain rosy filter of memory, provided a daily vision of a more romanticized Tunisia than ever really existed, so whatever the country had become by 1993 was going to be visually disappointing to me.

My ten young charges, however, were enchanted with the country in quite the same way I had been smitten with Lebanon when I arrived as a student in 1954 for my junior year abroad. Their rosy measuring stick began in 1993, with no comparisons to earlier times and with relative oblivion to the increased litter in the streets and to the many poorly constructed new hotels that obliterated formerly pristine beaches. I felt a certain envy for the unhampered freshness of their sixteen-year-old wonder as they were suddenly immersed in North African Arab culture. Tunisia did not have the appeal for me that it had on previous visits, but I found some of my old sense of adventure as I took them to the *suqs*, to the historic sites and museums, and to Sidi Bou Said, trying to see it all through their eyes.

We had two long bus tours around the country, staying in some of the second-rate tourist hotels that had mushroomed everywhere over the past decade and a half. In the daytime we stopped at Roman ruins and village markets, drove through the desert to see a troglodyte village, and traveled along the coast to the beaches I remembered as pristine and unspoiled. When we arrived at my favorite beach town of Raf Raf, we found a blight of ramshackle

development. A sweep of dilapidated cement-block houses covered the beautiful sand dunes and the beach that I had painted in 1971. When we visited one of these houses—the home of an American Peace Corps volunteer—there was a pleasant, neighborly feeling in the narrow streets and particularly in his house, where friends and neighbors dropped by throughout our visit. The congenial atmosphere helped only a little to diminish my disappointment in finding my favorite Tunisian beach ruined.

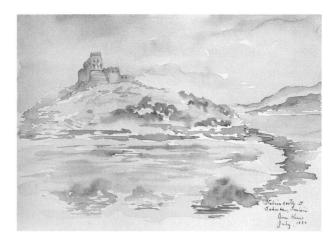

Italian castle at Tabarka, 1993

On this trip, instead of Raf Raf, I painted at another beach in the town of Tabarka, which had a broken-down but paintable castle offshore. Some of the students were interested in joining me, so we shared my brushes.

There I was with ten high school students sprawling over a small beach, some swimming, some sunbathing, and some sitting with me on big rocks painting this unnamed castle whose history we could only imagine.

Back in Tunis, the American ambassador and his wife invited the students

and me for lunch and a swim at the same beautiful Moorish house where Malcolm and I had stayed just after it had been completed. Almost two decades and many ambassadors later, the house looked quite different to me, but the view from the balcony where I had last painted Sidi Bou Said was relatively unchanged.

The ambassador's wife, who was a professional artist, had invited me to bring my paints. This was the first of several paintings of Sidi Bou Said I did that afternoon, temporarily freed of responsibility as the students splashed in the swimming pool and ate hamburgers in the company of the very hospitable ambassador. I welcomed the chance to absorb myself once again in Sidi Bou Said, although paintings of this charming town already outnumbered any other scene on the walls of our house in Pacific Palisades. I recalled shouts from my sons playing whiffle baseball in our living room as the foam

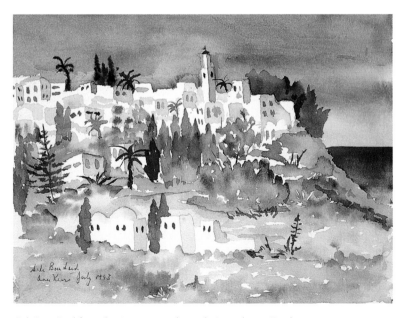

Sidi Bou Said from the American ambassador's residence, Carthage, 1993

rubber ball struck one of my paintings. "It's a line drive off Sidi Bou Said," they called out. But I was happy to have new renderings of this favorite scene to give to my students or to take home and add to my collection.

I have not been back to North Africa since 1993 as it is not central to my interests and involvement in the Middle East. North Africa remains a place of special magic in my memory from our early visits there. Perhaps the fact that I know less about it and have no ties to institutions there leaves room for more mystery—and less commitment. Tunisia and Morocco are frozen in time and only slightly overidealized in the paintings that hang on the walls of my home.

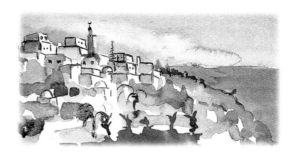

4

Egypt

If you drink from the waters of the Nile, you will come back again.

EGYPTIAN PROVERB

This proverb, repeated to me every time I go to Egypt, evidently works its magic, for I have returned again and again. While my first love affair in the Middle East was with Lebanon, the second was with Egypt. I have lived and visited there more than any other Arab country. Churchill's words ring true for me in his discovery of the delights of painting Egypt, with "its wonderful light—fierce and brilliant, presenting in infinite variety the single triplex theme of the Nile, the desert and the sun."

I first visited Cairo as an AUB student during the Christmas break. After visiting Bethlehem and Jerusalem, I flew to Cairo to meet a classmate who had relatives there. That was in 1954, shortly after the end of the Egyptian monarchy and the British colonial period and just as Gamal Abdul Nasser was coming to

power. With its wider streets and gracious art deco architecture, Cairo struck me as a well-planned modern city compared with Beirut. There were even department stores and traffic lights, advances unknown in Beirut at the time. I remember taking a tram from the suburb of Heliopolis, where we were staying, into downtown Cairo. From Ramses Station we took another tram out to the Pyramids, crossing the Nile over the King Fuad Bridge and looking out at the magnificent sails of feluccas carrying people and goods up and down the Nile. Once into Giza on the west bank of the Nile, we were soon passing through broad agricultural lands to get out to the Pyramids a few miles from the river. The fields were brilliant green with new shoots of winter wheat, dotted with an occasional *gamoosa* (water buffalo) turning a wooden wheel that drew water from the canals into the irrigation ditches.

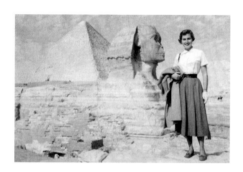

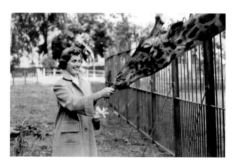

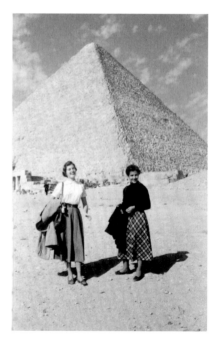

Clockwise from top left: in white gloves at the Giza Pyramids, 1954; with a friend at the Giza Pyramids, 1954; at the Cairo Zoo, 1954

The photographs in my album show two young women in the nicely tailored skirts and blouses of the day—my friend and me—in front of the Pyramids and Sphinx. I am wearing white gloves, as we did in the fifties. We explored the area mounted on camels, and I clearly remember enjoying this first-time experience on a camel whose name, so the camel driver told me, was California! He even whipped out a card with the name California on it and hung it around his camel's neck. He probably had forty-seven other cards in his camel bag with the names of all the other states of America at the time. My photographs also show the Cairo Zoo, well kept up in those days when Egypt's population was a fraction of its current size.

Another vivid image of that time in Egypt is of our overnight train trip to Luxor, sitting up all night on wooden benches three to a side, eating bananas and huddling together with other AUB friends to keep warm. Suffering through the cold night was made worthwhile by the sight that greeted us at dawn. Eternal Egypt passed before us in silhouette against the brilliant dawn, with village women walking gracefully toward the Nile, balancing clay jars on their heads to fetch water for the day, and *galibeya*-clad men guiding their

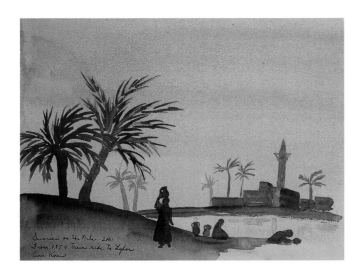

Painting from memory of Nile village life at dawn, 2001

*gamoosa*s out to the fields. Interspersed in these scenes were the fronds of tall date palms that lent themselves perfectly to this silhouette image of Egypt. As the sky brightened with the rising sun, these subjects took on color, but my initial duochromatic image of black silhouettes against the orange dawn is the one that remains with me.

More than the tombs and temples of Luxor, which have remained relatively unchanged, I remember the images of Egyptian life in those days, starting with the horse and buggy ride from the small train station over to the

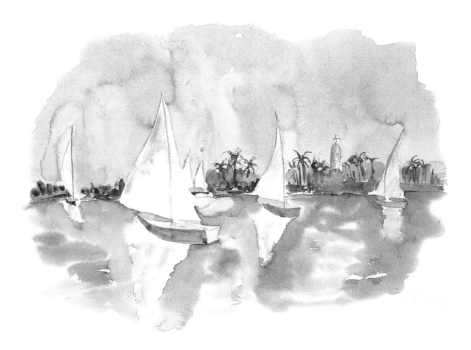

Feluccas on the Nile, 1977

Hotel Luxor. There were only a few hotels in Luxor in 1954 and only a few dusty unpaved streets in the town. There was one hotel that was grander than ours, the Winter Palace just up the street, but ours seemed grand enough to me, with its old colonial architecture and wide front porch facing out on the Nile. We ate our meals on the terrace overlooking the narrow corniche road between the hotel and the river.

I recall a few tourist shops and lots of colorful scenes of the daily life of the fellaheen, the Egyptian farmers whose lives on the farmlands of the Nile Valley had not changed much in the thousands and thousands of years that the land had been continuously inhabited. Farmers, sometimes with their wives and children, sat on their donkey-driven carts taking artfully piled loads of tomatoes, oranges, cabbages, and cauliflower to the Luxor markets. Just beyond the corniche were the high white sails of feluccas, turning constantly with the breeze, which I would discover some years later when I tried to paint them and had to paint faster than the wind to capture the light on the sails.

Ten years later in 1964, when Malcolm and I, with two young children, returned to Egypt on sabbatical from UCLA, these scenes of Nilotic life were still very much in place. The austerity of Egypt in the sixties meant that little building was going on and not much development of tourism. I remember driving around the fountain and small garden in the middle of Midan el-Tahrir, the center of Cairo, in our small Volkswagen, sharing the road with only a few other private cars and taxis. We could quickly be out in the farmlands or take a picnic to the Pyramids and find a quiet spot. Scenes like this one of the Giza Pyramids, painted some years later from the farmlands on the Saqqara Road, were easy to find in those days, but became harder to find each time we returned.

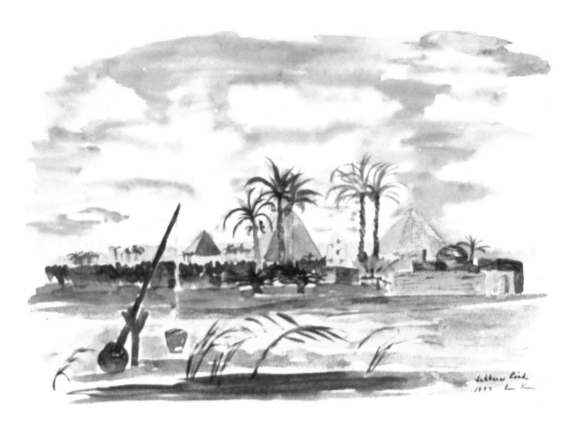

Farmlands near the Giza Pyramids, 1979

Our next sojourn in Egypt, twelve years later, came about as a second choice when civil war prevented us from going to Lebanon. We took our sabbatical in Cairo with our four children in 1976–77. Malcolm had been invited to be a Visiting Distinguished Scholar at the American University in Cairo, and we found a good American international school for our three boys. Our daughter, Susie, would take her freshman year at AUC.

The morning drive from the suburb of Maadi to the university in downtown Cairo took us on a ride through history. From the Nile Corniche, we could look across the river to the distant Giza Pyramids, built five thousand years earlier.

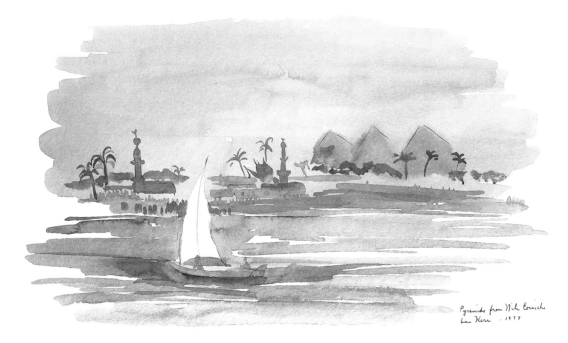

Giza Pyramids across the Nile, 1977

I painted this scene from a small fish restaurant on the Nile where I could sit in a quiet corner and be relatively undisturbed. The island in the river where the two minarets pop up is accessible only by boat and has retained its agricultural character, making this classic Nile-and-Pyramids scene possible. I carefully left out of my line of sight the monotonous cement block apartment buildings and factories that become harder to avoid every time I return to Cairo. Although Egypt and the Pyramids are practically synonymous, Cairo is also a treasury of unique Coptic Christian and Islamic monuments.

Further up the road from Maadi was Coptic Cairo, with its domed churches and ancient crosses testifying to the early roots of Christianity in Egypt going back to St. Mark. The designs of the Coptic cross intrigued me,

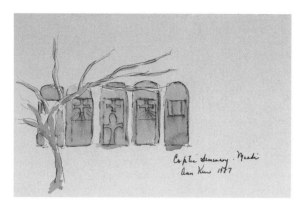

Coptic crosses in seminary windows, 1987

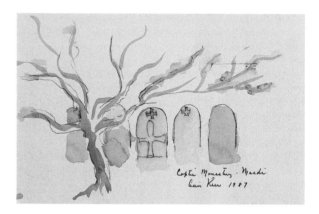

Coptic crosses in seminary windows, 1987

in particular a rounded cross resembling the pharaonic hieroglyph meaning "life." Some years later I painted several Coptic cross designs adorning the windows of the seminary across the street from my AUC apartment in Maadi.

From the Coptic quarter, our drive from Maadi into Cairo continued on past the old aqueduct that led up to the Citadel and Islamic Cairo. The Citadel can be seen from all over the city, topped by the Muhammad Ali Mosque, with its huge dome and high Turkish-style pencil minarets. The

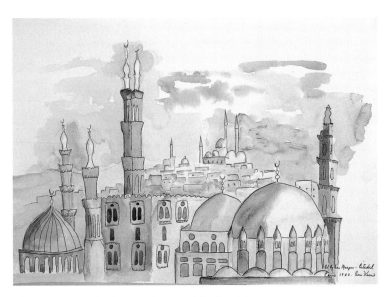

Skyline painting of Al-Azhar domes and the Citadel, 1980

Citadel on its high point above the city must have been significant as soon as the area of Cairo became inhabited, but it is generally associated with Salah el-Din, who defeated the Crusaders and came to Cairo in the late twelfth century. To the north of the Citadel stretched the old Fatimid city that is the heart of the treasure chest of Islamic monuments in Cairo, marking the city's skyline with a multitude of domes dominated by the tall minarets of the Al-Azhar Mosque.

This painting was done from the roof of the Hussein Hotel opposite the Al-Azhar domes. There was a café on the roof with an open space where I could go out and paint. The hotel, which had the same name as the popular mosque next door, was frequented by Muslim pilgrims and travelers.

The Hussein Hotel café was an ideal place to be during Friday prayers. The call to prayer rang out from the dozens of mosques in the area, merging

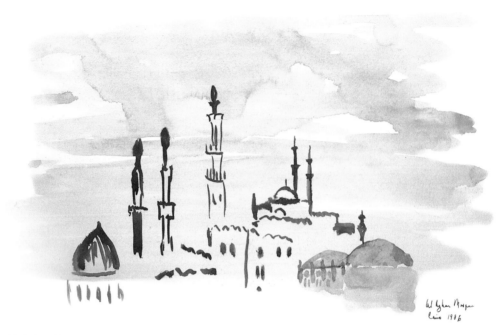

Al-Azhar Mosque, 1986

into a haunting medley as worshipers gathered in the square below, kneeling and waiting for the Friday sermon to begin. As soon as the sermon and prayers were over, the shopkeepers in the famous Cairo *suqs* reopened and commerce began again. I loved to scour the small alleyways extending out in a maze from the Hussein area where shopkeepers displayed their carpets, copper, brass, and glass wares. This is the Gamaliya area of Cairo, the setting for many of the books of Naguib Mahfouz, who won the Nobel Prize for literature in 1988. If one looked carefully behind and between the facades of the shops, one could find dusty remnants of exquisite Fatimid doorways and windows or old, hidden-away mosques. We had to break through cobwebs to climb the rickety stairs of the minarets.

From Bab Zuweila, the southern gate of the Fatimid city, we walked into

the colorful street of the tentmakers with its old roof from medieval days still mostly intact. Skilled craftsmen sat in their shops on raised platforms, legs crossed under them, handstitching red, blue, green, and white cotton cloth together into the traditional patterns used in tents for weddings, funerals and major religious holidays. I always took visitors there and if time allowed I also took them up to the Citadel and down to the Ibn Thulun, my favorite mosque and one of the oldest in Cairo, built between 876 and 879 A.D. One entered through two gates with a large empty space in between that acted as a transition from the outside world into the tranquility of the mosque. Immediately upon entering there was a sense of peace and escape from the clamor of the city and a feeling of awe at the immense courtyard surrounded by multiple aisles of majestic carved columns. The tranquility was interrupted only by the brusque manner of the gatekeepers as they sold us tickets and the required canvas tie-on covers to wear over our shoes—oblivious to the fact that they were interrupting one of the most moving aesthetic experiences in Cairo.

Every time I was in Ibn Thulun, I imagined myself sitting alone with my paints amidst the vast colonnades of this mosque, but it didn't happen until a brief trip back to Egypt in May 1997. Carrying my watercolor pad and paints in a bag of striped Egyptian cotton cloth made by the tentmakers, I hailed a

Susan Kerr at Ibn Thulun Mosque, 1977

taxi to take me to Ibn Thulun. I had to tell the driver how to get there, as it is not one of the main tourist attractions for people who have only a few days in Cairo. Finding a quiet spot to paint was easy as it is not a popularly used mosque.

This simple painting does not begin to capture the huge grandeur and austerity of Ibn Thulun; nor could any photograph. It is a place that has to be experienced in person. There is a strange combination of delicacy and immensity in the rows of massive columns with their distinctive decoration—

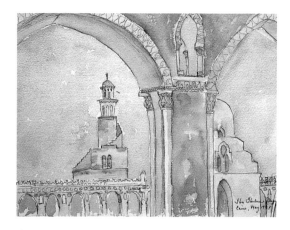

Ibn Thulun Mosque, 1997

and something poignant in their uneven tilt. Amidst all this magnificent human accomplishment, there is also unmasked imperfection. Sitting there with my paints in the company of a pigeon or two, I had time to reflect on all these things.

I remember the smell of the air as we returned to Maadi in August of 1979—warm, dusty, and jasmine-scented. It swept over me in a way that was both soothing and exhilarating, for I had missed Cairo almost viscerally since our last departure. We were to be at AUC for two years while Malcolm di-

rected the University of California Education Abroad Program and I studied for a master's degree. For me the fragrance of jasmine was almost synonymous with the Middle East.

We settled into an apartment opposite the Maadi Sporting Club, hired a cook and bought a secondhand Jeep Wagoneer so we could take trips into the desert. A favorite day trip in the cooler months took us to the monasteries of Wadi Natrun near the desert road between Cairo and Alexandria.

This painting evokes memories of an early January Sunday at the end of the Christmas holiday when both Susie and John were home from college for the Christmas break. We six and our cook, Ali, all crowded into the jeep for a trip to the Dayr al-Suryani Monastery at Wadi Natrun. There were four

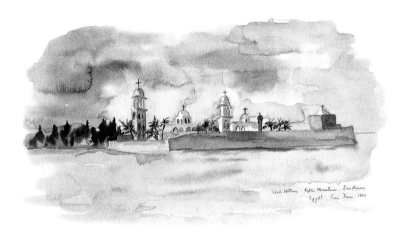

Dayr al-Suryani Monastery at Wadi Natrun, 1980

monasteries at Wadi Natrun, two quite close together and two further out in the desert beyond the paved road. Their origins go back to the early Christian monasticism that started in Egypt in the fourth century.

On the opposite side of the monastery from the side shown in this paint-

ing was a huge old wooden door with a hanging bell rope to ring for entry. "Is that someone who loves God?" a monk called out to us in Egyptian-accented English before he would open the door. He must have had a concealed peephole to peek out and decide whether he should speak Arabic or English to his guests. "Yes," we replied, and the door creaked open, revealing a smiling monk in black robes and the triangular black hat distinctive to Copts. He welcomed us into his ancient world of monks chanting in the Coptic language and the heavy aroma of incense.

After the visit we drove off the paved road into the desert to picnic and look back at the monasteries of early Christianity. The desert breezes were fresh and pure—good for picnicking and painting and for thinking how conducive this atmosphere was for monks through the ages to find peace and closeness to God.

Dayr al-Suryani Monastery
at Wadi Natrun, 1980

In Egypt there were always new places to see and visit. In the late spring of 1980 we took advantage of a long holiday to drive up to the Mediterranean shore where we stayed in the seaside town of Marsa Matruh, about halfway between Alexandria and the Libyan border. We had heard of a hotel on the

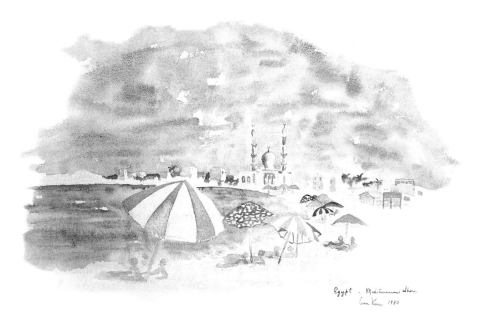

Marsa Matruh, 1980

beach, the Beau Site, which was supposed to have charm and good food—something rare in Egypt in those days. But this was not the Riviera, as we discovered when we entered the town and passed a string of car repair shops surrounded by old tires and litter. Marsa Matruh had the same ramshackle quality as most of the Egyptian towns we had visited—and an absence of city planning. Suddenly out of nowhere a huge modern mosque rose from the midst of some small shanty houses. New and shiny, it looked completely out of place in its ragtag surroundings. I managed to paint this romantic image of Marsa Matruh, showing none of its shortcomings, from the beach at the Beau Site.

It's hard to paint the Mediterranean without making it look romantic, especially on a white sand beach dotted with colorful umbrellas. These were particularly beautiful umbrellas made of strong Egyptian cotton. Even the town looked understandably romantic as a backdrop to the umbrellas and

with enough distance to give it a misty quality. The charming Greek-Egyptian couple who ran the hotel sat on the terrace above the beach with a coterie of friends, speaking a mixture of French, Arabic, and Greek. They seemed like a small vestige of the old polyglot international Alexandrian world that E. M. Forster, Lawrence Durrell, and other Western writers recorded—and probably overglorified as much as I overromanticized Marsa Matruh in my painting.

Maadi and Cairo were very peaceful in the summer as people moved to Alexandria where it was cooler or took vacations abroad. Those of us who stayed on felt a sense of shared pride in our toughness at withstanding the intense summer heat. One of the places we liked to go along the Nile was the Maadi Yacht Club. It bore no resemblance to yacht clubs in California, and that was part of its charm. It was a very simple place with just a few rowboats and sailboats and a modest restaurant above, which served mediocre food. In

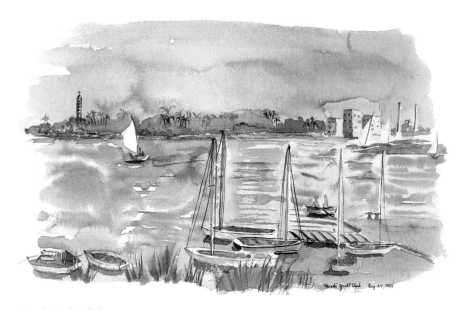

Maadi Yacht Club, 1980

the summer the flame trees were ablaze with coral blossoms, shading the tables where I sat to do this painting.

Among the small boats in the foreground of this scene is one that we rented so Andrew could take sailing lessons—a plan that never got very far but one we enjoyed thinking about. My favorite part of the painting is the felucca out in the middle of the Nile. It was so difficult to capture—getting the feeling of the wind in the sail and the forward motion of the boat. My eye immediately focuses on it when I look at the painting, and my memory turns to all the picnic suppers we took with friends on feluccas at sunset. Off to the right is the tip of an island with some distant feluccas hovering around it. This was Golden Island, a small uninhabited island that we often circled during our evening picnics. At twilight it loomed large beside us, with its high reeds and the birds settling down for the night. The green space across the river is now clogged with buildings, but from the painting I can remember the towers of Coptic churches topped with their crosses and the smokestacks of the old brickmakers in the far right of the picture that carried on a craft of many centuries.

In the winter of our second year of that sojourn in Cairo, my parents came to visit and we took them to see the wonders of upper Egypt. In Aswan we stayed at the Old Cataract Hotel, where we were greeted on our arrival by handsome old Nubian waiters clad in elegant striped cotton *galibeya*s. They looked as if they had come with the splendid colonial architecture of the hotel as they glided around with the quiet dignity characteristic of their race. Our rooms opened onto the front balcony overlooking the Nile, which was an ideal place to paint.

There is something about the bend in the river in this painting and the angle of the sails of the feluccas as they glide merrily down the river in the afternoon sun that makes it one of my favorites. The painting is a reminder too of the particularly beautiful colors in this region, with rose beige hills and the Nile a much clearer blue than it is near Cairo.

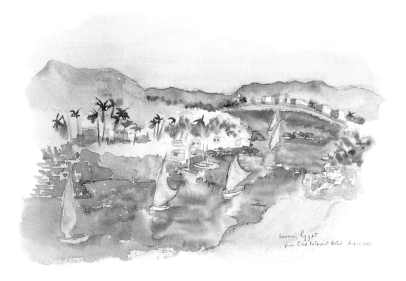

The Nile looking toward the town of Aswan from the Old Cataract Hotel, 1981

At night, when we went to sleep, we could hear the singing of the Nubian boatmen as they docked their feluccas and gathered to sing the songs of their ancient race. These African people had intermingled with Egyptians since pharaonic times and before, and there was an African quality to their music as they softly beat small drums to accompany their melodic chants. The town of Aswan, seen in the background of this painting, has always been a significant market town, being the last urban center before the Nile cataracts and the southern frontier of Egypt.

Just across the Nile from our hotel balcony was this view of the Aga Khan's mausoleum above the lively water and the rocks of the cataracts. A felucca maneuvered us through the rocks and over to the west bank where we climbed up to visit the imposing mausoleum, the final resting place of Aga Sir Sultan Muhammad Shah, the leader of the Ismaili Shiite sect of Islam, buried there in 1957. The mausoleum was built in neo-Fatimid style, following one of the most beautiful styles in Egypt's rich architectural history. The lines of the domes and arches were similar to those of my favorite mosques in the Al Azhar area of Cairo.

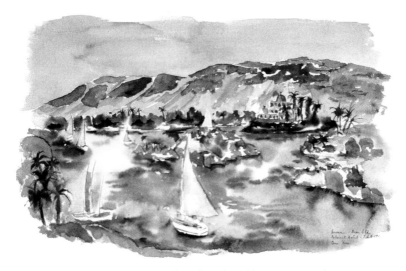

The Nile and the Aga Khan Mausoleum from the Old Cataract Hotel, 1981

During that two-year period in Egypt we discovered the delights of camping at the Red Sea. John had come for a sophomore semester at AUC from Swarthmore College and Susie could occasionally come to visit from Jerusalem, where she was teaching at St. George's School. We were usually

several families strong, bonded together by a mutual love of the outdoors and by children of similar ages. There was fishing, snorkeling, exploring the island, and eating the delicious food we all brought and shared. On good fishing days there was fish to cook over an open fire on the beach.

Giftoon Island in the Red Sea near Hurghada, 1981

Our most frequent destination was Giftoon Island, which we dubbed Bentley Island in honor of the family who were the chief organizers of our trips. Camping there was a rustic affair. These three rickety boats brought us from the mainland with all our gear and remained with us for the duration of our stay. I don't remember anyone worrying much about being an hour and a half from shore and without any sort of communication equipment. We put our faith in the remarkable ingenuity of the boatmen. If an engine broke down they always knew how to fix it. If there were terrible winds and high seas they miraculously got us to our destination. If no one in our party caught any fish, they caught some, cooked them on the boat, and brought them to us to add to our dinner.

The color scheme of the Red Sea islands was basically duochromatic, beige and blue, with shades and variations that changed with the time of day more than with the weather, which was almost always sunny. The real contrast came underwater where, with a snorkeling mask, one beheld a whole world of never-before-seen colors in the multitude of fish swimming in and out of coral beds and seaweed forests. Their yellows, oranges, greens, and blues took on a fluorescent aspect under water that completely disappeared

Red Sea beach with shells, 1981

when a fish was brought ashore. Undisturbed by human visitors, some of these fish would swim right up to us as if we were just a bigger version of them. They might have sensed that we were not predators underwater, but I wondered if they knew that others of our species were dropping lines to catch them. These magical fish served both aesthetic and culinary purposes on those camping trips—and they looked different underwater than they did on our plates!

That two-year sojourn in Egypt came to an end in June 1981. My next stay in Egypt would be under very different circumstances. I lived there with John and Andrew after Malcolm's assassination in Beirut for a period that stretched out to five years.

I remember in those early years after Malcolm's death how Egypt seemed to absorb some of my grief. I could walk in the streets of Cairo and let the tears fall anonymously behind my sunglasses, alone but not alone on the crowded streets. The sights and sounds and smells of this city, with all of its colorful vitality and pathos, drew my sorrow into it. Images of its ancient monuments and the myriad faces of its people so unmasked in their emotions filled my mind and tempered my sadness. In Midan al-Tahrir, the pivot of downtown Cairo just outside the AUC campus, the faces of traffic policemen were sometimes vainglorious, sometimes despairing, and sometimes baffled at the impossible car and pedestrian traffic they were supposed to control. There were laughing girls shopping in Midan Suleiman Pasha, ogling brilliantly lighted display windows filled from floor to ceiling with shoes of all colors and styles. Nearby, shoeless and sometimes footless beggars sold pencils or Chiclets, seeming not to notice, or to have long ago accepted, the irony of the lavish shoe stores. *Galibeya*-clad men from the countryside walked along in groups, carrying food from a street vendor, on their way to a construction site where they had found employment and might spend several months residing until the building was completed. These workers from the country, walking purposefully in the streets of Cairo, looked as much at home as the policemen, the shoppers, the beggars, and the tourists. This city had a way of absorbing all of us. My sadness merged into all that I was seeing and, at least for a while, my personal story seemed no more or less important than any of theirs.

At Christmas time in 1984, our first without Malcolm, John, Andrew, and I were invited to visit friends in Sanaa, Yemen. This would be my second trip to Yemen in four years. The first had been with Malcolm in 1980. On each

trip I painted a view from the same window of the beautiful old traditional Yemeni house that served as the American ambassador's residence, looking out on the city of Sanaa.

Sanaa's striking gingerbread high-rises—tall, narrow, three- or four- or five-story mud brick houses—were trimmed with white curlicues and lacy designs. The curlicue decoration carried right over to the mosque with its very domed minaret—distinctive features I had not seen in mosques elsewhere.

Sanaa from the American ambassador's residence, 1981

In spite of their multi-stories, these buildings had a miniature quality about them. Everything in Yemen seemed to be on a smaller scale: the people, the shops, the *suq*s. The diminutive Yemenis wore black clothing with colorful accents: the women, billowing robes and sometimes elaborate face veils,

Sanaa from the American ambassador's residence, 1984

the men, baggy-bottomed pants and checkered turban headdresses. There was a special refinement in their intricate silver craftwork and basket designs. The artful mounds of spices in the market, in a variety of velvety earth tones, made it quite easy to believe that the Three Wise Men had come from this region when they brought their gifts of frankincense and myrrh to the Christ child.

John was now working with Catholic Relief Services, and he and his colleagues occasionally combined their work projects around the countryside with sightseeing. They were generous in inviting me along. One of our most memorable trips was in the spring of 1985 to Minya, halfway between Cairo

and Luxor, over the Easter/Shem-el-Nesim holiday. Shem-el-Nesim is the ancient spring festival of Egypt that dates back to pharaonic times and often falls around Easter, allowing a double holiday. Our trip included a felucca ride on the Nile that gave me a chance to paint.

From this watery painting done in the late afternoon sun, it's hard to imagine the dust and shabbiness of the city. Old houses with walled gardens offered a hint of graceful architectural lines that could barely be detected beneath what looked like decades of neglect. Along the Nile there was an un-

Minya from the Nile, 1985

kempt grassy corniche with lots of shade trees where people strolled and children played. Even this city beside the river could not escape the relentless dust and sand of Egypt, blowing in from the surrounding desert. But like everywhere else in Egypt, the surroundings became secondary and unimportant when one encountered the people, who were full of gusto and humor.

After haggling and joking with the boatmen, we hired a felucca for the day and set sail north with the river on its way to the Mediterranean. Along both shores were the rich agricultural lands that had brought John and his friends to the area for the agricultural development projects of Catholic Relief Services. We moved with the timeless flow of the river, watching the agricultural life of the felaheen that had been going on for more centuries than we could fathom. This historic continuity became more vivid when we stopped to go ashore and stretch our legs, never suspecting the sights in store for us in the village on a rise above the riverbank.

The village of Dayr al-Adra, a two-hour felucca ride north of Minya, was one of many places in Egypt named after the Virgin Mary, commemorating one of the stopping places on her flight into Egypt with Joseph and the Baby Jesus. As we approached the village we heard chanting coming from the church and decided to go and explore. Near the entrance the air grew hazy and pungent from incense wafting out. Speaking in an Arabic dialect of the countryside, which one of our Egyptian friends from Minya could understand, a man near the door explained to us that it was Good Friday and farm families had come into the village to commemorate the crucifixion of Christ. We could barely discern the source of the incense until our eyes grew accustomed to the thick haze inside and we were able to spot two brown-robed priests swinging their smoking brass incense pots from long chains. Our noses too had to adjust to the conglomerate aromas of the earthiness of the farmers, the mustiness of the church, and the overwhelming perfume of the incense. I could just make out the figures of farmers and their families crowded into the simple room lighted only by candles and a small window or two, chanting texts that were perhaps biblical, perhaps relics of pre-Christian rites. These were the accumulated religious practices of thousands of years, rooted in this agricultural society far from urban influences. We might have been in the tenth century, or even the fifth, and things probably would have been much the same.

This quick rendering of Dayr al-Adra was done from far out in the river as we approached the village. All the paintings I did that day had to be done rapidly to capture a scene before we sailed past. The immediacy and enforced concentration created by these conditions enhanced the watercolor process. I sat in the back of the boat with my paints, absorbed in the passing scene.

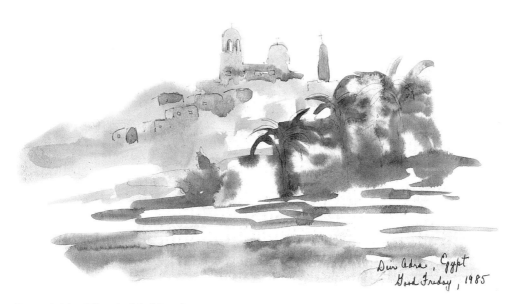

Dayr al-Adra (Church of the Virgin), 1985

At Christmastime in 1985, we treated ourselves to a more luxurious cruise on the Nile. The whole family came along—all except Steve, who was now playing basketball for the University of Arizona and had a Christmas tournament in Alaska. Susie and her husband, Hans, came from Cambridge, Massachusetts, and our cousin Seth Handy from Providence, Rhode Island. The views of Egypt drifting by reminded me of the sights I had seen on the train ride to Luxor thirty years earlier during my first trip to Egypt, at Christmas-

time in 1954. Our travel conditions were a lot more comfortable than that cold and drafty train, and taking this trip with our children was something that Malcolm and I had always hoped to do.

This painting reminds me of the satisfaction of painting from boat to boat, as I had done on the felucca trip from Minya. Being only a few meters

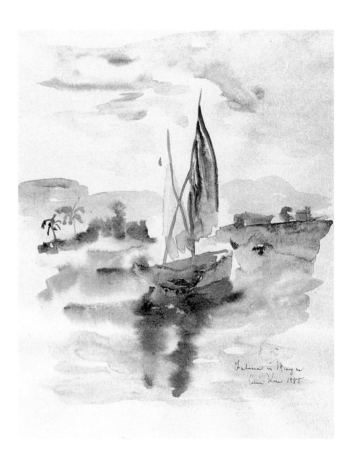

Single felucca on the Nile, 1985

away from a lovely vessel like this one made it possible to feel almost one with it; we were poised together far from the distant shore. Although my natural home was not the water, I could get a sense of what it might be like by concentrating on this single felucca, looking so graceful and ephemeral, almost part of the river around it, and yet plucky and self-contained. The colors of the boat and the water seemed to merge into each other, the sails taking on the hues of the Nile and their reflected forms becoming part of the water.

The desert had a similar effect to the Nile in fostering a sense of timelessness and oneness with nature. Beyond the narrow strip of blue bordered by stripes of green lay the endless beige of the desert. The river would have been

Painting from Nile boat, 1985

less significant without the stark contrast of these barren land masses stretching beyond it on both sides. Being in the desert brought a feeling of tranquility and, like the Nile, a sense of continuity. It was easy to understand why the early pharaohs had built their pyramid tombs between the green agricultural strip and the vast Sahara on the west bank of the Nile. My favorite pyramids were at Sakkara and Dashur, south of the more famous third-dynasty pyramids at Giza and constructed a dynasty or so later.

Here is a photograph from our first visit to Dashur in the winter of 1964–65, when we picnicked there with friends. The footprints of our combined families were the only ones on the large sandy plain in front of the pyramid that day, long before the boom in tourism. Dashur was then only a short drive south of Cairo on the lightly traveled roads leading out to the countryside.

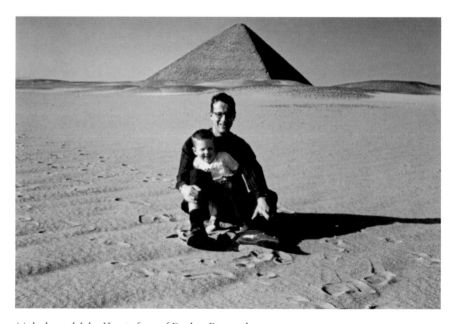

Malcolm and John Kerr in front of Dashur Pyramid, 1964

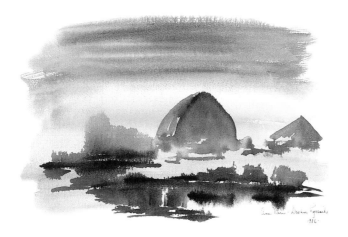

Dashur Pyramids, 1986

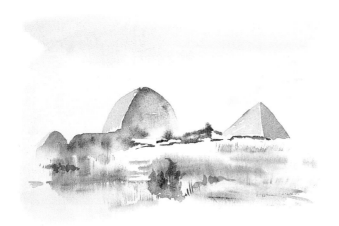

Dashur Pyramids, 1986

These paintings of Dashur were done in 1986, when I was invited to spend a day with AUC friends at their small weekend house at Dashur. We drove from Maadi early on a Friday morning, the Muslim sabbath, when the usually chaotic streets on both sides of the river were still uncrowded.

A few commercial establishments and extravagant weekend houses were beginning to sprout up among the pristine palm groves near Sakkara, an ominous sign that this exquisite repository of ancient Egypt might become like the Giza Plateau, where the urban morass encroached right up to the Pyramids. My friends' house was on a small road at the edge of the agricultural land with a few neighboring cottages tucked between palm and mango trees. Just across the road was this stunning scene of a pond and one of the lesser pyramids of the Dashur complex behind it. In the far distance was the largest and most notable of the Dashur pyramids. The small pyramid behind the pond looked as though it had worn down with age, although it might also have started out as a so-called bent or rhomboidal pyramid.

My hosts explained that, according to regional lore, King Farouk used to hunt in Dashur in the days before the Aswan Dam was completed, back when the Nile flooded annually and made the pond large and inviting for ducks. On that sparkling winter day, far from the polluted air of Cairo, there were no ducks and not another human being in sight except for an occasional farmer. The deep blue of the small pond created a complementary color to the olive green vegetation around it and a striking contrast to the beige of the desert sand and the pyramids. There was a feeling of remarkable privilege in having this little patch of pyramids all to myself for an hour or two.

By the time I painted the second version of this scene, the sun was higher in the sky and the colors had grown less dramatic. The paler colors of the second rendering were probably also the result of having less paint on the palette and wanting to use up the remainder before I finished for the day. With less paint I had to use more water, which created the pastel effect.

A year after our first Nile Christmas cruise in 1985, Andrew and I repeated the journey with some AUB and AUC friends. I knew it would be a painting trip when our hometown friend Andy Hales wanted to come along from France, where he was studying art. Painting on the Nile was the perfect way for this young student to spend Christmas in Egypt.

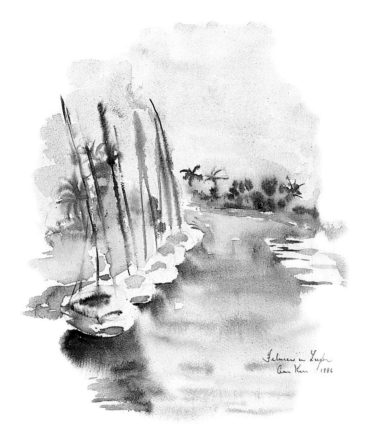

Feluccas docked in Nile canal, at Luxor, 1986

We flew to Luxor to embark on our cruise boat, and before we sailed I painted these feluccas moored on the riverbank. They had a quiet, stately look in their stillness that was very different from seeing them with full sails blowing in the wind. Here they assumed a different appearance, halfway between land and water and without their human or material cargo. In their empty state they were a nostalgic reminder that, along with the camel, these traditional means of transportation were now, after thousands of years, being replaced by more mechanized vehicles.

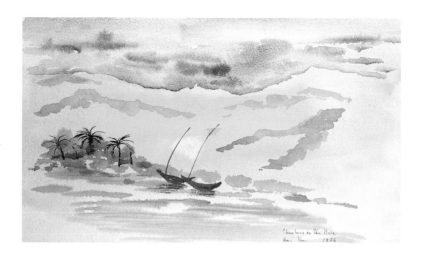

Christmas painting of feluccas on the Nile at Aswan, 1987

We sailed from Luxor to Aswan, stopping along the way to see temples and tombs. In between stops, Andy and I found a nice out-of-the-way place at the back of the boat to sit with our paints, poised to catch the changing light along the Nile. The late afternoon sun was my favorite, casting a golden light

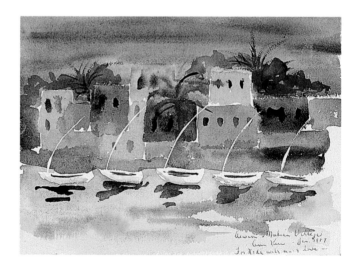

Village houses on the Nile near Aswan, 1987

on everything. It was so overwhelming that I just dipped my brush with a lot of water into the blob of Naples yellow paint and painted a golden wash over the entire paper. Then I added the other colors, some while the paper was still damp to get a muted effect, and then the sharper lines of the boats and palm trees after the wash had dried.

When we reached Aswan, we found that some of the village houses were painted in bright yellow-orange and burnt sienna, in contrast to the more common mud brick or cement block houses we had been seeing.

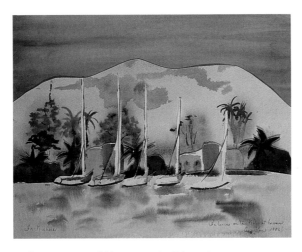

Collage painting of feluccas on the Nile at Aswan,
1986–87/1994

Here is another painting of the colorful Aswan village houses and feluccas, but a careful look will show that it is actually a collage. The idea came to me when my daughter-in-law, Margot Kerr, asked if I would do a painting for the bedroom of my grandson Nicholas. I was thrilled with the assignment and thought that the colors should be bright and cheery and that the subject

matter should have something to do with the exotic travels of Nick's fore-bears. I did not find anything suitable among my Egypt paintings, as I had given away the ones I liked. Among the rejects, however, there were some features in different paintings from our two Christmas cruises that looked as if they could be put to good use. I found a few bright-colored Aswan houses, some palm trees, some feluccas on a sunset-colored Nile that picked up the colors of the houses, and a strip of hillside riverbank with some misty trees against a nondescript sky. I cut all these salvageable pieces out and experimented with putting them together in a collage. A new sky was needed, so I painted one in a shade of blue that would match Nick's room and pasted all these pieces onto it, one layer on top of another.

When Churchill wrote about the brilliant light in infinite variety he found in painting Egypt, he spoke of the Nile and the desert, but he did not mention the Red Sea. He must not have gone there, for the changing light at the Red Sea was as dramatic as anything in Egypt. We had discovered the pleasures of camping there during Malcolm's and my last stint together in Cairo, and now I went back frequently and always took my paints. There was

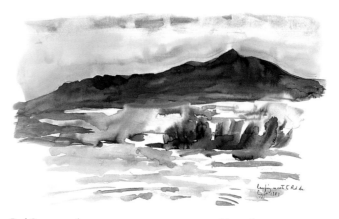

Red Sea coastal mountains at sunset en route to Hergada, 1987

a unique pleasure in making these trips several times a year with good friends who shared a mutual love of the beauty and isolation of the area and of the swimming, snorkeling, and fishing that awaited us when we got out to the island we claimed as our own. These friends were like an extended family for me and being together at the Red Sea on intermittent trips over a decade bonded us for life.

Giftoon Island at sunset, 1987

I loved to paint at the end of the day when the duochromatic color scheme of daytime blue and beige took on evening shades of pink, gold, purple, and orange. At this hour the seagulls were having their last look for tasty morsels in the sand before the sun dropped behind the hills along the mainland coast.

After dinner we settled into our sleeping bags and watched the nighttime display of stars in an uninterrupted arc of sky. It seemed as if there were more stars than sky. Like the fluorescent fish, the stars could be seen only in full glory when certain conditions existed. We had to be underwater with the fish

to see the wonder of their colors, and looking up on a moonless night to have the best view of the stars. The sky formed a black background for the limitless stars that looked like a speckled mass of silver. Unlike the sea, where we knew that no matter how deep it was, the surface of the earth was somewhere underneath, looking into the night sky offered a glimpse into infinity.

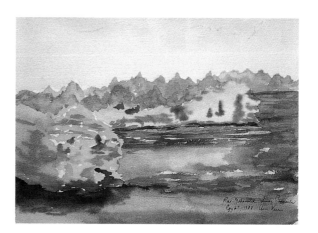

Ras Muhammad, 1988

Painting at Ras Muhammad, 1988

Another of our favorite places on the Red Sea was at Ras Muhammad at the tip of the Sinai Peninsula. Between 1967 and 1980, this area had belonged to Israel, which had maintained it as a nature preserve. When the Egyptians regained the land they had tried to do the same but were less experienced in organization and management. Still the area was spared from the rampant tourist development that would soon take over other places along the Red Sea. Ras Muhammad was a favorite place of John, Andrew, and some of our friends, who liked to dive from the high rock cliffs into the sea. Here also was one of the most beautiful coral reefs in the world, where only certain species

Andrew Kerr and friends jumping from cliffs at Ras Muhammad, 1988

John Kerr jumping from cliffs at Ras Muhammad, 1988

of sea life could be found. They would scuba dive in the depths while I preferred to swim around the surface within easy access of dry land, looking through my snorkeling mask from the sunlit surface down past the layers of all varieties and colors of coral through the deepening shades of blue.

In 1987, Andrew and I were invited to spend the Christmas holiday with friends in Sudan. We had a chance for an inside look at Khartoum and its more African sister-city, Omdurman, between which the Blue Nile and the White Nile joined.

I painted this picture from the garden of a private home as a souvenir of Khartoum. The tree in the left foreground is all I painted of the garden where I was sitting. There were distinguishing features that made the landscape

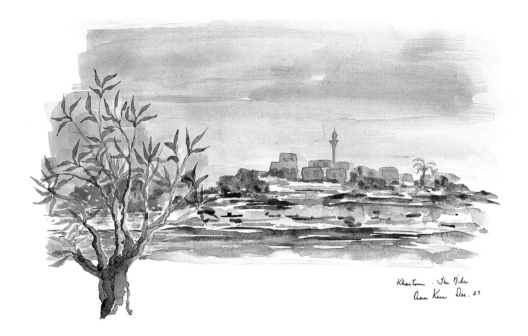

Nile village near Khartoum, Sudan, 1987

different from that of Egypt. In Sudan the color of the river seemed a deeper blue, perhaps because the much smaller population created less pollution or perhaps because it was closer to the source. The mud houses made from the Nile soil were a darker, redder brown than similar houses in Egypt, and there was a feeling of openness and a lack of crowdedness in the countryside and even in the city. Khartoum was striking to one coming from Egypt in this lack of overcrowding. I observed few changes since my previous visit twenty-three years earlier.

A vivid recollection from that earlier trip to Sudan—besides being introduced to the delicacy of peanut soup—was sitting on the terrace of the Grand Hotel in Khartoum in 1964 where Western guests, including us, were reading the recently published books by Alan Moorehead, *The Blue Nile* and *The White Nile.* These books recounted the history of the search for the source of the Nile and the quest of earlier adventurers to understand a part of the world previously unknown to the West. David Livingstone, Richard Burton, Lady Hester Stanhope, T. E. Lawrence, and Gertrude Bell were names that conjured up images of great adventure and discovery. For those of us so drawn to this part of the world, their exploits reflected its lore and appeal, enhanced by the passage of time and our own susceptibility to its mystique.

I knew that I could not stay in this part of the world forever. In the summer of 1988, I decided it was time to draw myself away from Egypt and return to live in our family home in Pacific Palisades. My mother's death that summer and my wish to be near my father in his widowhood were the catalysts that made me decide it was time to go home. I would spend one more semester in Cairo to bring my life there to a close and then move home to California. Those last few months in Cairo were a time to reinforce all the images of the life I loved so much there and would take home with me in tangible and less tangible forms.

During those last few months in Cairo I visited some of the places I had missed or always wanted to see. Here is the Nile Valley at Beni Hassan. I

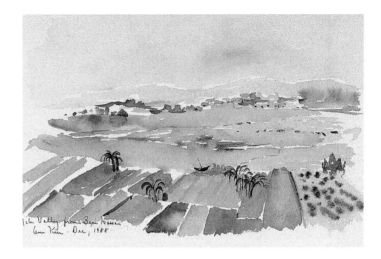

Nile Valley at Beni Hassan, 1988

painted this scene on an AUC trip to visit the tombs of eleventh- and twelfth-dynasty noblemen, built into cliffs above the Nile.

I found a quiet place to paint on the hillside below the tombs, looking down over the valley. In the short time available, I somehow caught an image that I liked of this expansive view of the valley—the varied colors of the farmlands, the island in the Nile where fishermen found a place to spread their nets, and the small town of Beni Hassan on the east side of the river. This was an unspoiled view of Egypt that was becoming more and more endangered. As impressive as the monuments of ancient Egypt were, I was more captivated by the beauty of the countryside and more worried about its survival. Efforts were being made to preserve the monuments but the urbanization along the banks of the Nile was happening without proper planning. Each time I traveled outside the city, I saw the same pattern of poorly constructed apartment high-rises or industrial buildings usurping fertile farmlands. It seemed to me that these buildings should have been built a few miles back from the Nile on nonarable lands.

One of my concerns in leaving Egypt was the future of our housekeeper, Ali, who had worked for us for a total of seven years. His dream was to retire and open a small café on some family property near his village. He often spoke about this village on an island in the Nile north of Aswan, the only access to which was by felucca. The name of the village was simply Gizirit al-Nil, meaning "island in the Nile." There were no cars or roads on the island. My images of the romance and charm of peasant life soared when I pictured this remote place. It was a place I had to visit before moving back to California. Each evening, as Ali and I went through the accounts for his daily shopping—fifty piasters for carrots, seventy-five for tomatoes, a pound and a half for milk—we would make our plans for a trip to the village. After working together for seven years, Ali and I almost intuited each other's thoughts. He had never learned English, but we managed with my basic Arabic and the common understanding that comes of long years of friendship.

To the other passengers on the overnight train to upper Egypt we must have been a strange sight—a foreign woman in Western dress traveling with a rural Egyptian dressed in his finest *galibeya*. Ali's brother met us at the train

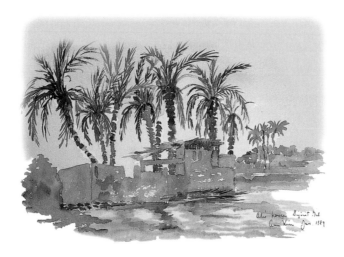

Ali's father's house on Gezirit al-Nil, 1988

station in the small town of Durrah and took us by local taxi to the ferry crossing. The access to the island was at a small beach below a bluff with a wide, steep path winding up to a date palm orchard. Here under the palms was the house that Ali's father had built many years earlier.

Ali had told the story many times of how his father had built this house of mud and palm branches with his own hands. It was very peaceful when I sat painting it, with only an occasional goatherd passing by. The house was now uninhabited but its value lay in the palm trees around it, each of which was owned by a certain member of the family who reaped the harvest and the income from it. The family land on the mainland, where Ali wanted to build his café, was less easily divided. A few years after I had left Cairo, I learned that the money I had given Ali to help build the café had been eaten up by government fees, family squabbles, and legal entanglements over the ownership of that land.

I painted one more watercolor in those last weeks of travel when I visited friends in the British Embassy in Addis Ababa and discovered the birthplace of a famous British explorer of the Arabian Peninsula. Scattered around the embassy compound were a few woven grass-roofed cottages that caught my eye because they looked so different from all the other, more European-style buildings. My hosts told me that one of these cottages was the birthplace of Wilfried Thesiger, who had spent years exploring and writing about Arabia. His parents had been British civil servants working in Ethiopia at the time of his birth when the country was still known as Abyssina. In his autobiography, *The Life of My Choice*, Thesiger describes these cottages as comfortable and spacious with great charm.

I had heard tales of Thesiger's solitary forays in the 1930s across the famed Empty Quarter of Arabia, the Rub' al-Khali, which he recorded in a book called *Arabian Sands*. Thesiger rests in my imagination with other earlier Middle East adventurers whose exploits I would have liked to share—at least in my imagination. I thought with envy of his chance to explore Arabia be-

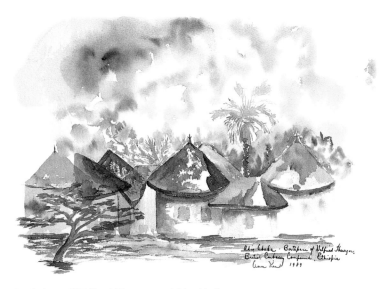

Birthplace of Wilfried Thesiger in Addis Ababa, 1989

fore the discovery of oil. There would have been no discarded rubber tires or plastic bags or oilcans littering the desert floor, no pipelines or fumes from the refineries. I imagined Thesiger moving across the endless sands of the Empty Quarter by camel, and I wondered how the light looked and what the silence was like.

It had been a long time since my first trip from Heliopolis out to the Giza Pyramids in 1954. The thirty-five-year interval between those days and my 1989 departure from Cairo had brought many changes. The steady erosion of local culture in exchange for something more modern and homogenized is a phenomenon I have been witnessing since I first started traveling to the Middle East. I try to put this in perspective by remembering the thoughts of Edward Lear, the English artist and writer, who visited Egypt five times between 1849 and 1872.

On a trip to Cairo after a five-year absence, he observed in his journal how much the area of Cairo had changed, especially near the Pyramids. On

October 13, 1872, he wrote, "Nothing in all life is so interesting as this new road and avenue—literally all the way to the Pyramids!!!—I could really hardly believe my own senses remembering the plain in 1867" (quoted in Mary Anne Stevens, ed., *The Orientalists: Delacroix to Matisse, The Allure of North Africa and the Near East* [New York: Thames and Hudson and the National Gallery of Art, 1984]).

When I take students to the Middle East these days I wonder how they can have any interest in this overpopulated, polluted, aesthetically unpleasing environment, where cement has replaced nature and children grow up in parts of the Nile Valley hardly knowing the color green. Yet I am continually surprised by the students' reactions and watch with pleasure as I see many of them responding to the region in the same way I did almost half a century ago—with wonder and enchantment. Some of these students have gone on to specialize in fields with a Middle Eastern emphasis, which will consume them for a lifetime, as the subject has me.

Perhaps we share something with Edward Lear, who predicted, in a letter written to a friend before he left on his first trip to Egypt in 1849, that "the contemplation of Egypt is something that must fill the mind, the artistic mind I mean, with great food for rumination of long years" (quoted in Stevens, ed., *The Orientalists*, 1984).

5

The Holy Land

Jerusalem: The city of peace (Hebrew)
Al-Quds: The holy city (Arabic)

While the Holy Land is not a place where I have lived or painted extensively, it is pivotal to the conglomerate picture of the experiences that I have described in these pages. I use the term *Holy Land* to mean Jerusalem and the area immediately around it that is sacred to the three major monotheistic religions of the world, Judaism, Christianity, and Islam.

For me the name Jerusalem rings with childhood Sunday school images, hymns, and biblical passages that were part of the attraction that first led me to Lebanon. Feelings of the sanctity and centrality of the Holy Land to the Christian culture in which I grew up still linger, and I subconsciously believe that the two watercolors of Jerusalem hanging side by side in my house gain a little extra value and merit merely by having been painted in that holy city.

My first visit to the Holy Land was in 1954 when I was invited by one of my AUB classmates, Widad Irani, to her home in Bethlehem for Christmas. I was still new to the Middle East and more familiar with biblical images than political realities. The opportunity to go to Bethlehem and Jerusalem seemed almost unreal. Remarkably, my illusions of the beauty of the landscape were not spoiled.

In those days the town of Bethlehem was still a place of fields and shepherds, olive groves, and starry skies. The Irani home was a simple, unheated structure with a large balcony overlooking an olive grove. The warmth of the family's hospitality made up for the winter cold as we all sat huddled together around a small charcoal brazier drinking tea or toasting our bread for breakfast over the hot coals.

These photographs remind me of Widad's handsome white-haired father, who taught Arabic to British and American missionaries living in the area, and

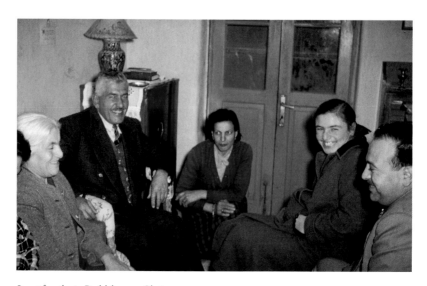

Irani family in Bethlehem at Christmas, 1954

Irani family in Bethlehem at Christmas, 1954

of the radiant face and pink cheeks of her mother as she came in from gathering pine boughs to decorate the house for Christmas. Our holiday meals included the delicious tabouli, hummous, and kibbeh dishes she made for us. I remember standing on the balcony on Christmas Eve, looking for the star of Bethlehem—and seeing many in the brilliant winter sky. We went to Shepherds' Field that night to sing Christmas carols with other members of the Western and Palestinian Christian community, of which the Iranis were a part.

My next trip to Jerusalem was six years later in 1960, when Malcolm, his younger brother, Doug, and I made a driving trip through Syria and Jordan to Jerusalem. We stayed just outside the Old City in the American Colony Hotel, a place started by an American family who had come to Jerusalem a

century earlier to find spiritual uplift and who stayed to do medical work among the poor. The American Colony Hotel was a stunning example of the gracious nineteenth-century stone architecture of the Arab countries of the eastern Mediterranean that I had first discovered in Beirut. There were wrought iron balconies and a flower-filled inner courtyard where we had our

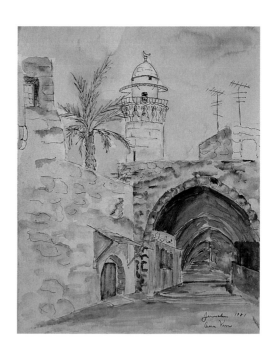

Narrow street inside the Old City of Jerusalem, 1981

breakfast. Some of the walls were decorated with the famous Jerusalem tiles made by several generations of an old Armenian family living just up the street. In those days the hotel still had a missionary sparseness about it. This simplicity set off the beauty of the architecture and gardens to good advantage.

From the hotel it was a five-minute walk to Damascus Gate and into the Old City. The street had a distinctive feel to it, with its simple stone architec-

ture and the aroma of sesame-covered bread being sold from small sidewalk carts. Jasmine climbed up the old stone walls, adding more fragrance to the air. There was an intimate atmosphere of friendly chatting among shopkeepers and local shoppers that extended to us strangers. Children in spic-and-span uniforms marched along to or from school. The proprietors of tourist shops were low-key and didn't seem to pounce on tourists the way one might expect in a city where tourism had been going on for two thousand years. One almost forgot that this was the Holy City of three major religions. Perhaps I imagined it, but I thought the Palestinian people along the streets had a greater sense of knowing where they belonged than did the people of Beirut, who were so easily drawn to every latest trend from the West.

Passing through the narrow streets inside the walls of the Old City, we came to the Temple Mount, a place of tremendous sanctity to both Jews and Muslims and so archeologically intertwined that it was impossible to know where the sacred site of one stopped and that of the other began. Here, on top of the remains of the second Jewish Temple and the Wailing Wall, was Al-Aqsa Mosque, the third-holiest mosque in Islam after Mecca and Medina. Our Egyptian cook, Ali, dreamed of making a pilgrimage to Jerusalem almost as much as he dreamed of going to Mecca. "At Al-Aqsa," he told me, "one prayer is worth a thousand in my mosque." Opposite Al-Aqsa was one of the earliest and most beautiful examples of Islamic architecture, the Dome of the Rock, which for Muslims commemorated the place where Muhammad ascended to heaven on his white horse. For Jews and Christians it was the place where Abraham had offered to sacrifice his son Isaac and was spared by God from having to do so. The Muslims have the same story, but for them it was not the son of Abraham's Jewish wife, Sarah, who was offered for sacrifice but the son of his Egyptian wife, Hagar. This site, as much as any place in Jerusalem, symbolizes the historical intertwining of Judaism, Islam, and Christianity.

I did not see Jerusalem again for almost twenty years. In 1979, two years

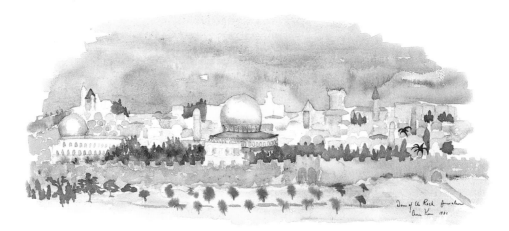

Dome of the Rock, 1981

after the historic meeting in Jerusalem between Egyptian President Anwar Sadat and Israeli Prime Minister Menachem Begin, an agreement was made to open the borders between their two countries. Malcolm and I were living in Egypt at the time and could not wait to travel overland to Jerusalem. We decided to do so in the fall of 1979 with Steve, Andrew, and a young friend of theirs.

A trip that would have taken a few hours on a modern highway took the whole day because of lengthy border procedures and rough roads, but the sights along the way and the interesting people we encountered made it worth the long day. I have vivid mental pictures of that journey—the desert crossing to Ismailiya and the gentle farmlands of grapes, mangos, and citrus as we approached the town from the desert. We left our car at the canal crossing to take a launch (pronounced "lunch" in the local vernacular) to the Sinai, which had been returned to Egypt as part of the peace agreement. The little boats made their way back and forth across the canal, navigating between huge ships from all over the world, traveling between the Mediterranean and

the Red Sea in the morning and taking the opposite direction in the afternoon. The ripples in the water from the movement of the launch caught the sunlight, and beyond stretched a long strip of blue bordered by crests of beige sand. Far off in the distance loomed a large ship almost completely filling the width of the narrow channel.

Ship passing through the Suez Canal in Ismailia, 1979

From the launch we traipsed up a sandy bank on the Sinai side of the canal to a flat area where several old taxis were waiting for customers like us who wanted to be driven to the Israeli border at El Arish. Life for most of the inhabitants of the Sinai had probably not changed much in the few months since this land had been returned to Egypt, but there were new business op-

portunities for these drivers of old diesel-fuel Mercedes. We bargained for the best price and set off for a harrowing ride across the top of the peninsula.

Except for United Nations vehicles and Israeli military equipment, these roads had not seen much traffic since Gamal Abdel Nasser lost the Sinai to Israel in 1967. I remember whizzing along the road at a terrifying speed, weaving around the occasional banks of sand that collected on the road, some of it blowing into our mouths and eyes through windows that were left wide open to give relief from the scorching heat. There was no commercial development of the land—only an occasional village or Bedouin camp and an infrequent glimpse of the Mediterranean when the road came close to the shore. The ruins of large rusty tanks protruding out of the sand told the sad history of Arab-Israeli wars, yet looked benign compared to the potential risks of the vehicle in which we were riding at what felt like breakneck speed. Memorable sights in the foreground against the beige backdrop were Bedouins going about their daily routines near their tents or tending their goats out in the open land. The Bedouin women presented a stunning contrast to the neutral shades all around them, with their colorfully embroidered black dresses and the intricately carved silver jewelry that served as their personal bank.

The rundown condition of El Arish gave the impression that it had always been a border town, though there were some signs of Israeli infrastructure and a sight that was striking to us coming from Egypt—street signs in both Hebrew and Arabic. The novelty of its border status was evidenced in the paper flags strung across the streets in celebration of the new peace and the makeshift hotels with names such as Salam-Shalom and Friendship written in Arabic, Hebrew, and English. Our sense of relief in reaching the border without mishap bucked us up for the long customs procedures we knew lay ahead. In fact they took so long that it was too late to make the last leg of our trip to Tel Aviv, and we had to find a room in the Salam-Shalom Hotel that night, much to the chagrin of the boys.

The next day we found a taxi to take us to Tel Aviv. These taxi drivers were a different breed from their Bedouin cousins in the Sinai. Also of Arab background, most of them were Israeli Arabs whose families had not fled Palestine in the 1948 Arab-Israeli War and had grown up learning to speak some Hebrew, a language closely related to their native Arabic. Hearing this taxi driver switch from Arabic to Hebrew to speak to the Israeli border guards brought home the fact that I was in Israel for the first time in my life.

Our route took us through Gaza, the most impoverished of occupied Palestinian lands. Israeli soldiers stopped us at frequent checkpoints—a sad counterpoint to the masses of refugee camps that had filled Gaza for more than thirty years. A new generation of refugees had been born in these camps, and a new generation of Israelis was guarding them—children of the Palestinian refugees and Israeli soldiers we had seen twenty years earlier, children whose lifetimes had been filled with war and hatred. They had no memories of the pre-1948 days when some of their forefathers and mothers had managed to live together in the same land. The soldiers at the checkpoints looked so young, only a bit older than my own sons.

From Gaza we drove north through fertile farmlands to the coast and then to Tel Aviv. The land was beautiful, with vineyards and orange groves all impressively well-tended. There was an atmosphere of peace and bucolic tranquility. In these surroundings I had to keep reminding myself that I was really in Israel—the country that I had thought of with fear wherever I had been in the Middle East over the past three decades. In Beirut, the name Israel was never mentioned in social gatherings. Americans might refer to it as "Dixie" or "down south" in a subdued voice. Looking out at the peaceful farmlands we were passing, I could not summon up the fear that I thought I should be feeling.

In Tel Aviv, where we met Israeli colleagues and former students of Malcolm's from UCLA, I came face to face with something I had not antici-

pated. In the two days we spent there it became apparent that there was tremendous fear among the Israelis for the Arabs. It was eye-opening to realize that the Israelis were just as afraid of the Arabs as the Arabs were of them—perhaps for different reasons, but their fear was palpable. The Arabs feared the military power of the Israelis, and the Israelis feared the fact that they had four enemy Arab nations on their borders and an Arab population within their country.

One of our goals on that first overland trip to Israel in 1979 was to visit the office of the University of California Education Abroad Program at Hebrew University in Jerusalem and meet our counterparts, who ran the program that Malcolm was directing for a two-year stint at the American University in Cairo. From Tel Aviv we drove to Jerusalem, entering on the Jewish side of the divided city and continuing past the Arab sector and the great city wall, built in 1538 by Ottoman Sultan Suleiman the Magnificent. I was shocked to see the Israeli settlements that had been built on formerly bare hills, massive housing developments surrounding the city that in effect created a new city wall.

At the Education Abroad office we were met by the program administrator, Chana Arnon, a slim, effervescent woman who was also the mother of four and an activist in liberal Israeli politics. Out of that meeting an idea was born that became a yearly tradition: we would have an exchange trip between Cairo and Jerusalem for University of California students. Malcolm and I would take our students up during the semester break and Chana would take hers down over the Passover holiday.

The overland trip from Cairo up to Jerusalem and Tel Aviv, either with students or by ourselves, became almost routine for us, and the sense of adventure remained in spite of the lengthy border procedures. We were delighted when, after Susie's graduation from Oberlin College in 1980, she decided to take a job for a year teaching at St. George's School in Arab

With Chana Arnon at the American Colony Hotel, 1998

Jerusalem, just down the road from the American Colony Hotel. She could come home for holidays, and we could go up for long weekends whenever we had the chance and stay with her in the St. George's compound.

Our trips to visit Susie in Jerusalem and the fact that she resided there

With Susan and my parents, Sue and Jack Zwicker, at St. George's Hostel, 1981

With Susan at the American Colony Hotel, 1986

gave us a familiarity with the Old City that made me feel I could add it to "our" cities in the Middle East and North Africa—Beirut, Cairo, and Tunis. I especially felt that way when I took my paints and sat on the Mount of Olives or under the sixteenth-century walls by myself, contemplating this holy terrain with its synagogues, mosques, and churches that had meant so many different things to so many people for thousands of years.

In order to find the best view to paint the Mount of Olives, I climbed up a hill below the city wall through a cemetery, where a ragtag guard looked as if he were going to tell me I couldn't be there. I kept walking, pretending not to notice him, and found a good spot far away where I could lean against the historic wall and set my paints out beside me. The whole Mount of Olives lay before me. I started with the sky to get the outline of the hill and the little Christian village that formed the skyline. The intricate design and decoration of the gold domes of the Russian Orthodox Church halfway down the hill captured my imagination and my paint brush. Less than a hundred years old, the Kremlinesque church was a latecomer to this holy scene. The place

Mount of Olives from the Old City of Jerusalem, 1980

synonymous with the Mount of Olives is the Garden and Church of Gethse-
mane where, according to the New Testament, Jesus prayed three times to
God to spare him if it be His will. "Not my will but Thine be done" (Luke 22:
42). Soon thereafter Judas betrayed him with a kiss.

I had had my first view of Gethsemane with Widad Irani and her fiancé,
Kamel Kawar, in 1954 when they took me to visit the garden and church. In
that year the Russian church domes had not been regilded and there were no
buildings at the top of the hill. The olive trees, which a priest had told us were
the descendents of those from the time of Christ, were now twenty-seven
years older. So much had changed in the intervening years, but the glowing
light was the same. The whole hillside looked as if a halo surrounded it.

My two Jerusalem paintings are almost obverse views. I painted this
scene of the Old City many times from the same spot in a grove of olive trees,

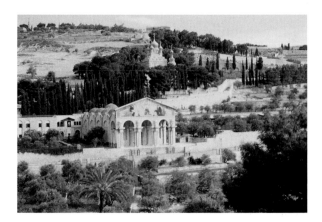

Mount of Olives from the Old City of Jerusalem, 1954

just across a small valley from my other perch below the city wall where I painted the Mount of Olives. When I look at my Jerusalem paintings I can almost smell the warm sun on dry grass under the olive and cypress trees where I sat up behind the shining gold domes of the Russian Orthodox Church.

I think of my first sight of this stunning view when Widad and Kamel took me to the top of the Mount of Olives to gaze at the Jerusalem skyline and then to explore the city. I remember my surprise as an American Protestant, seeing the ornateness of the holy places commemorating the major events of Christ's life and the evidence of sectarian competition for preeminence in these places. In the Church of the Holy Sepulcher, which is the traditional place of veneration of Christ's tomb, the central area downstairs was dominated by the Greek Orthodox and Roman Catholics. Their attempts to outdo each other in showy splendor were alleviated by the fact that the Orthodox Christmas fell almost two weeks after the Roman Catholic Christmas. The chandeliers in the Greek Orthodox sanctuary were draped with dust covers on December 25, as if declaring themselves temporarily closed to business. Off in other corners of the church were the smaller sanctuaries of

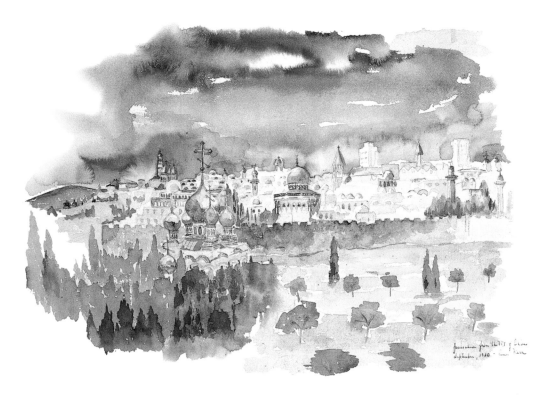

Old City of Jerusalem from the Mount of Olives, 1980

eastern Christian sects, which had been dominant enough in the Middle Ages to stake a claim to a place near the presumed site of Christ's tomb. Among them were the Greek Catholics, the Syrian Orthodox, and, in an upstairs chapel, the Armenian Orthodox. The scent of incense burning in profusion for the Roman Catholic Christmas wafted around ornate pillars and brocade-draped altars throughout the church.

As I sat on the Mount of Olives painting this scene of the Old City of Jerusalem, the archeological and architectural symbols of the three major monotheistic religions poking up over the walls looked deceptively harmonious. The blue-tiled and gilded Dome of the Rock dominates the skyline; to

its left is Al-Aqsa Mosque. The Wailing Wall, the sacred destination of Jewish pilgrims, cannot be seen here. Behind the Dome of the Rock and to the right are the minarets of mosques in the Arab section of the Old City. The Jewish quarter is to the left, and as can be seen from the steeples and crosses, Christian monuments are scattered throughout the Old City.

The color of the old walls changed as the sun moved through the sky. These walls had protected the city for centuries of Muslim rule during the Ottoman Empire, but now the troubles came from within the walls between the children of Sarah and Hagar. These Semitic cousins had come to adulate their separate holy sites as symbols of national pride, and each wanted to make their capital here. Each branch of the children of Abraham believed their promised land lay in the regions around this city.

The glow in my painting of the Mount of Olives and the architectural harmony of the religious monuments in the Old City of Jerusalem are only part of this watercolor. The city that has inspired so much art, music, poetry, and spiritual revelation has also witnessed intolerance, war, and alienation. In all the pictures one could paint of the Middle East, will it ever be possible that Jerusalem/Al-Quds might become, according to its Hebrew and Arabic names, the city of peace and holiness, the capitals of two promised lands?

That is the picture I would like to paint with my watercolors.